Historic England

Sussex

Kevin Newman

AMBERLEY

For David Akers – the history teacher everyone deserves.

First published 2019

Amberley Publishing
The Hill, Stroud, Gloucestershire, GL5 4EP
www.amberley-books.com

The publisher is grateful to the staff at Historic England
who gave their time to review this book.

All contents remain the responsibility of the publisher.

ISBN 978 1 4456 9207 4 (print)
ISBN 978 1 4456 9208 1 (ebook)

British Library Cataloguing in Publication Data.
A catalogue record for this book is available from the
British Library.

Typesetting by Aura Technology and Software
Services, India. Printed in Great Britain.

Contents

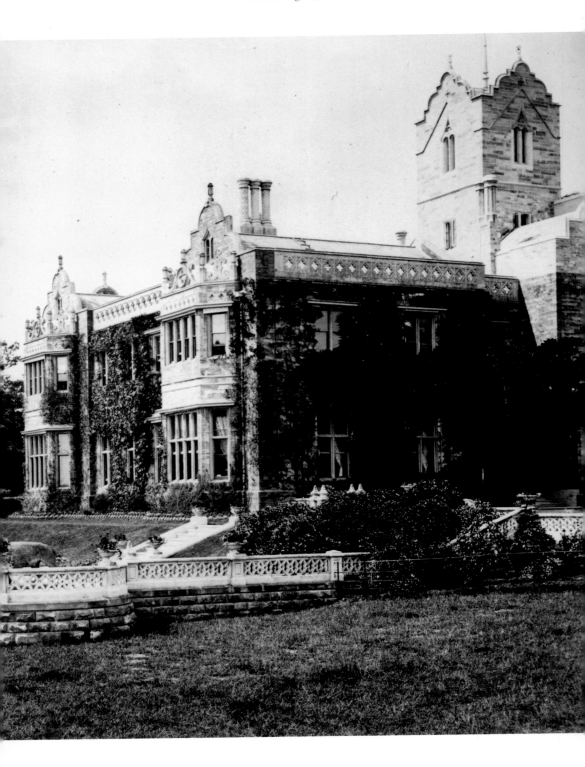

Introduction

There are many different ways we can look at the history and heritage of Sussex. The chronological route is logical and aids understanding of each era but poses problems with themes such as industry or literature that transcend particular eras. There are also questions as to how and when you divide up the past. Taking a random approach, as previous former Sussex newspaper editor Mike Gilson urged me to embrace for the newspaper supplements I wrote for them, was scary at first but then liberating. Ricocheting across themes and time throws up logical patterns and questions we don't always think of when approaching the past in a sensible fashion. Approaching the past through its images and observing themes through categorisation is also a valid and interesting approach, as we explore here in the *Historic England* series. Thanks to the Historic England and Britain From Above archives, we are offered a new perspective on our county.

Apart from the opening chapter, each chapter takes the reader on a journey of sites on the chapter's theme from the west to the east of the county, rather than in chronological order. So readers could use the book to plan trips if they wish. As Sussex was the Kingdom of the South Saxons, there is no better route to travel than that of Aelle, Cissa, Wlencing and Cymen – westwards.

As somewhere that has been a kingdom in its own right, a gateway to England, battlefield, agricultural breadbasket and livestock larder, it is no surprise that Sussex has a large archive of historical documents, diagrams and pictures. In more recent centuries it has been an escape route to exile for Charles II, an aristocratic adventure ground, playboy's playground and real estate for royalty. It offered havens to health-seekers, a stomping ground for smugglers, and a destination for day trippers. Today it provides a paradise for painters and photographers, rural retreats, spiritual refreshment for ramblers, and even seclusion by the seaside.

Sussex is unusual since not only was it a kingdom in its own right and a hard-to-access part of the country from the north or west, it was ignored partially by some of the effects of the Industrial Revolution. Sussex preferred to be typically awkward and have its industrial era in the sixteenth and seventeenth centuries instead. Sussex largely avoided the major conflicts of the Civil War of the 1640s and even was determined in places like the Trundle to hold meetings refusing to be either with the Crown or Parliament. It seemed perhaps that after turning-point battles like Hastings and Lewes, the county had done its part; but no, it would be needed again at the time of the Armada, and in the two world wars of the destructive twentieth century. Even the Cold War didn't leave Sussex untouched.

Today, Sussex is peaceful and still largely rural, although its urbanisation is a work in progress as some green fields turn concrete grey and bleak with business parks. Thankfully the recent creation of the South Downs National Park has guaranteed a green spine throughout the county, protecting Kipling's 'blunt, bow-headed, whale-backed Downs' equally beloved by him and our other great adopted Sussex patriot Hilaire Belloc. Being blessed with the nation's thirteenth national park means Sussex must always look backwards as it moves forwards, but then that is what Sussex has always done best.

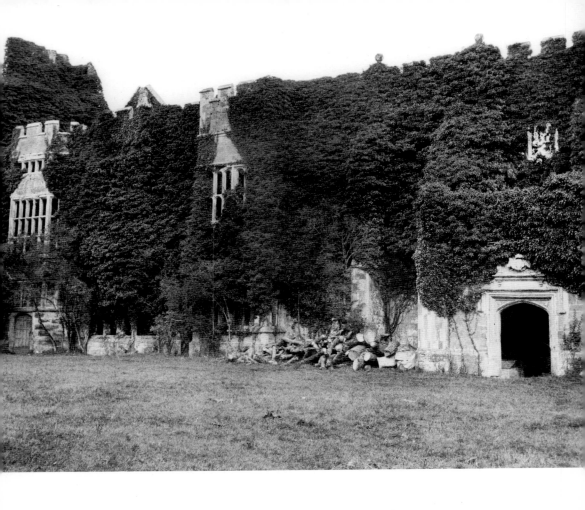

Landmarks and Scenery

We start our tour through these archives with causes, places, events and scenes that brought people to Sussex. Sussex today needs to provide no explanation as to why visitors should come here, with its verdant countryside and captivating coastline, but in the days when the Weald was near impenetrable, its roads near impassable at times and the coast perceived as a hostile universe, causes for migration here were less clear. When Sussex became separated from the continental mainland by the English Channel the biggest cause for migration was invasion and it is these invaders of Sussex left their mark, as this chapter shows.

Pevensey

Pevensey's medieval inner walls with Roman walls of 'Anderitum' (as the Romans called Pevensey) in the background. The viewpoint of the image below includes walls built by the Romans, and used by Saxons and Normans since then, as well as the castle's other occupiers. It reminds us why Pevensey has lasted for seventeen centuries. The photographer would have been standing in a tidal harbour as recently as the Middle Ages. Pevensey was built on a peninsula (the 'ey' in its name suggests 'island' or 'promontory') and so it overlooked and was the gatehouse to what was a wide expanse of water making the then Pevensey Bay. Here we see the southern, Roman-built walls the sea would have once lapped up against, and whose erosion led to their partial collapse. We can see here all the walls before restoration and removal of the flora they are covered with. (Historic England Archive)

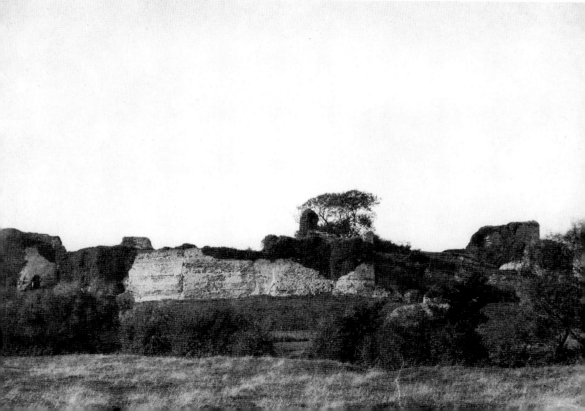

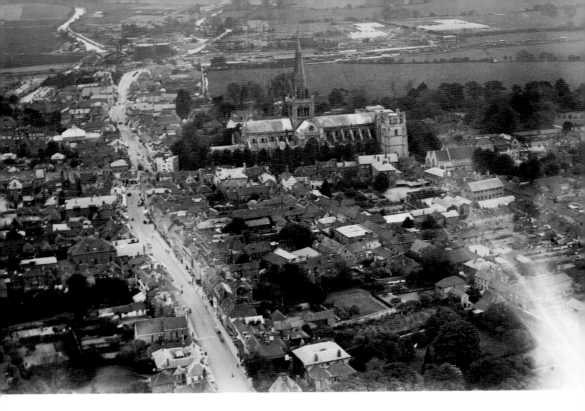

Chichester

This south-facing photo reminds us that Chichester was a market town for the Romans where two roads crossed and around which a town was constructed on the flat plains near its harbour – today the small village of Dell Quay. Chichester was convenient as west–east roads would meet north–south here, with Stane Street coming off to the north-east heading up to the new Roman capital of Londinium. (© Historic England Archive. Aerofilms Collection)

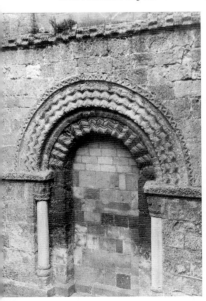

Chichester Cathedral

This image reminds us of the changes to Sussex's geography as well as its government as first Saxons and then Normans invaded and seized control of the county. St Wilfrid built the first Sussex cathedral, probably near where it is believed the Saxons landed at Cymensora, today off the coast of Selsey. By the time of the Normans, Selsey was under attack instead from the waves and so the Normans would build Battle Abbey to give thanks for their successful landing and victory there. They had less need for the Saxon cathedral at Selsey and so it was left to the sea and a cathedral was established instead at Chichester. Capturing and building a cathedral in the city the Saxon leader Cissa had given his name to (Cissa's Ceastra) suggests perhaps the Normans were also reminding the populace that they controlled sacred Saxon territory now and that by building a cathedral they had the ear of God. This image of a bricked-up, twelfth-century doorway in the south-west tower of the cathedral reminds us of this changing role of Chichester, but that the city would still be vital to the Normans and would continue to grow and evolve. (Historic England Archive)

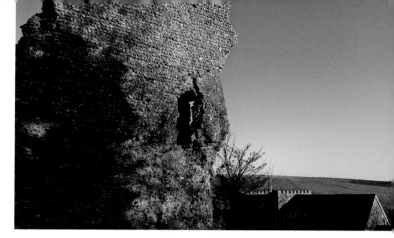

Bramber
Many of the sites the Normans would later build on were the burhs (fortified towns/castles) of the Saxons. The clue that King Alfred ordered a burh to be built at Bramber is in its name, along with the more westerly Burpham. Here we see the largest remaining part of Bramber: its gatehouse. (Author's collection)

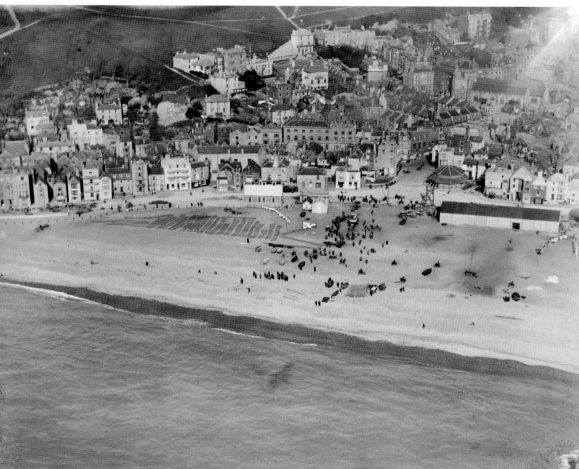

Lost Harbours – Hastings, Brighton, Worthing
The Saxons were likely to have approved of what is now Sussex as the rivers and more numerous harbours at that time mirrored the north German and Danish coastlines. Worthing, Brighton and Hastings all had small harbours and the small rivers that fed them are today under the ground. (© Historic England Archive. Aerofilms Collection)

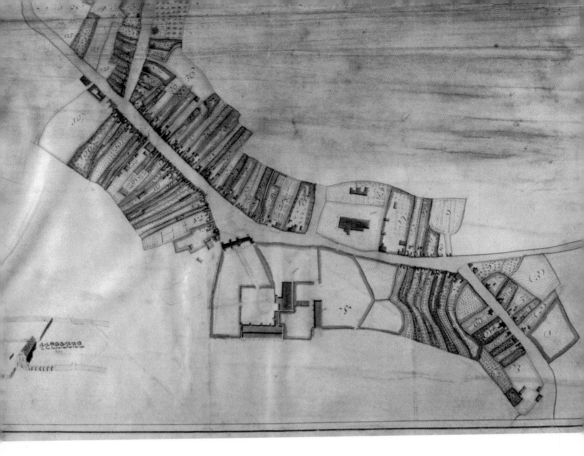

Above and opposite: Battle Abbey

The Normans came here to claim the throne of England and land promised to William of Normandy, including especially Sussex land at Bosham. Harold's breaking of his promise to support William's claim to replace Edward the Confessor led to battle on Sussex soil. This took place north of Hastings, in a battle that would take the name of the last settlement the Normans were in before battle. Where Harold supposedly fell, William promised to build Battle Abbey as a mark of thanks and penance for his slaughter and you can still see the abbey of 1070 and possible battlefield site today. This plan shows the town of Battle, Battle Abbey and land immediately north of the town, the present site of Caldbec House.

Establishment of the abbey encouraged Battle town's growth and spread. Today the town is one of East Sussex's tourist hotspots, featuring the abbey cared for by English Heritage and the High Street (also shown above), a necklace of tea shops, great inns and quirky retail premises. Both Battle's parish church and the abbey were originally dedicated to St Martin and are worth a visit. Battle is a beautiful and peaceful place, ill befitting the site of not only one of England's bloodiest battles but, as Barbara Willard said in the 1965 book *Sussex*, it is the site of 'the sharpest turning-point in England's history'.

As the Black Death of the 1340s, the Peasants' Revolt and Jack Cade's 1450 rebellion made Sussex more dangerous for landowners, crenellation and fortification of properties took place. This had the double benefit of protection from French raids as well as internal disturbances. As we see here (opposite above), the gatehouse at Battle Abbey was built in 1338. Lewes Castle (page 14) also gained a gatehouse in this era, as did Michelham Priory (page 16). Wealthy properties of the gentry sometimes gained moats if the buildings themselves were not fortified. The gatehouse is the view of Battle Abbey from the north front. (Historic England Archive; © Historic England Archive. Aerofilms Collection)

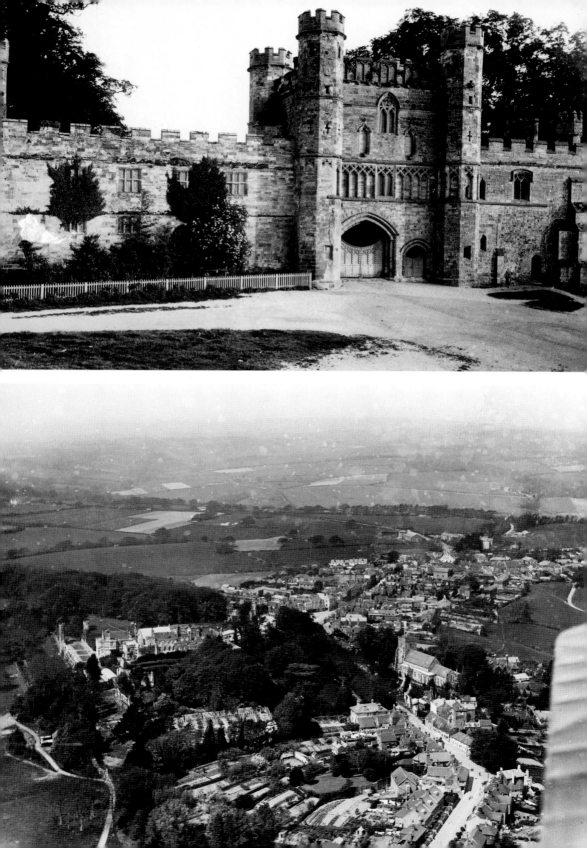

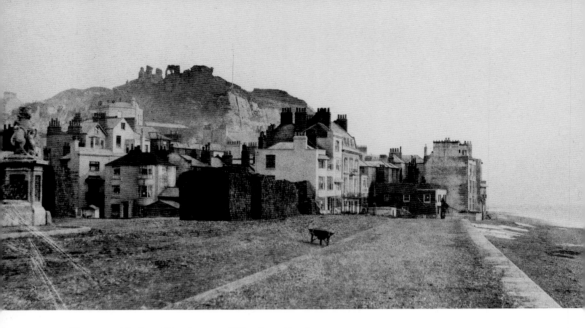

Above and below: Hastings and Hastings Castle

The Normans had to secure the 'gatehouse to England', which they had used Sussex as. William's most loyal lieutenants were all ordered to occupy a 'rape' (section) of Sussex running from north to south and in return could build a castle and charge rents there. Previous Roman and Saxon sites were used, or easy to defend sites. Hastings is certainly the latter, as we see here.

The remains of Hastings Castle are shown from the west in this image (below) from 1855. You get an idea from this image of just how much the Normans wanted the castle to dominate the town and for the conquered Saxons to know exactly who was boss. Even with part of the castle destroyed due to coastal erosion, it still is the main feature of the town and shows the grip the Normans had over the country with their programme of castle building. (© Historic England Archive. Aerofilms Collection; Historic England Archive)

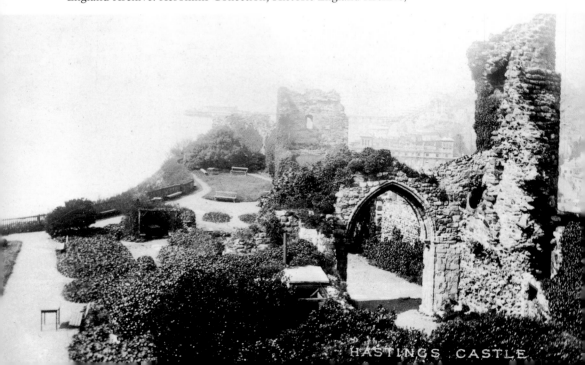

HASTINGS CASTLE

Above and overleaf: Lewes Castle

Built by William I's son-in-law William de Warenne, Lewes Castle was constructed probably on the Saxon burh ordered by Alfred the Great. By the thirteenth century the monarch's power had receded while that of his barons had grown, leading to the castle's involvement in the Battle of Lewes in 1264 when Simon de Montfort fought the forces of Henry III outside the town at Mount Harry. Both castle and town (that we see here in the late nineteenth century) were spoiled in the events of the battle. (Historic England Archive)

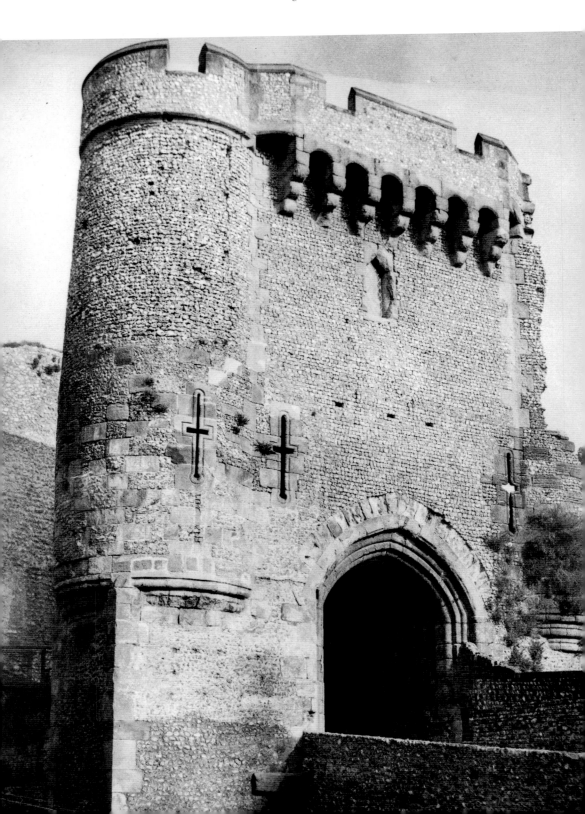

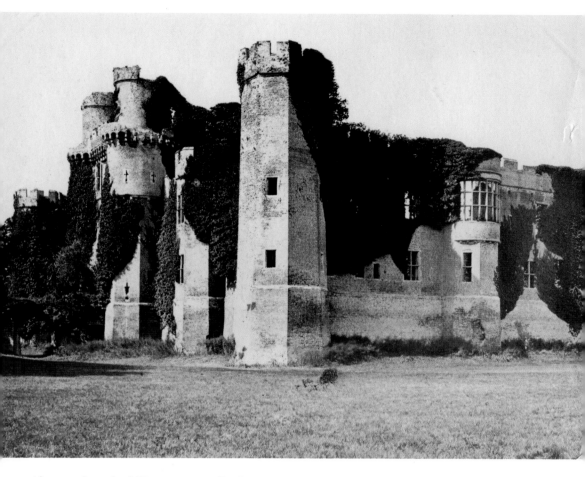

Above and overleaf: Herstmonceux Castle

Sussex was still under threat by the later Middle Ages due to the Hundred Years War with France (1337–1453). Fear that the French would use Sussex's (then much wider and navigable) rivers to reach deep inland gave rise to further castle building at the interior sites of Bodiam, Amberley and Herstmonceux and the fortification of manor houses. They held the dual purpose of protecting the owners from the populace too – this was the time of the Peasants' Revolt (1381) and Jack Cade's rebellion (1450). As this was now the beginning of the era of gunpowder, Bodiam and Herstmonceux (dating from *c*. 1441) would never have defied sustained attack with cannon, rather they were built to impress, as they still do today and as Herstmonceux here did even in its pre-restoration state in the Victorian age. Lewes and Michelham Priory also gained gatehouses at this time. (Historic England Archive)

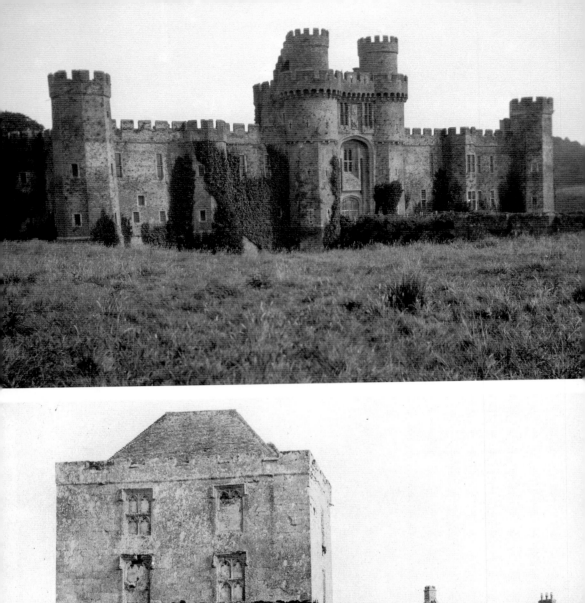
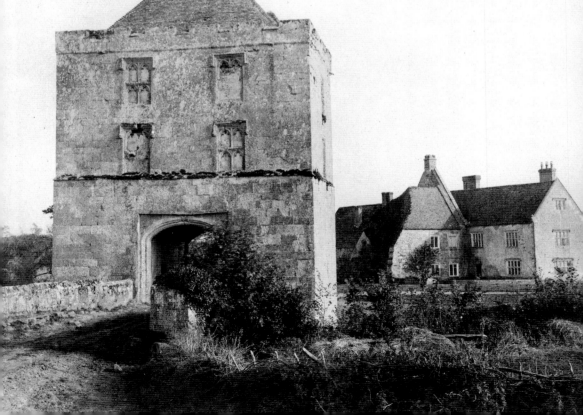

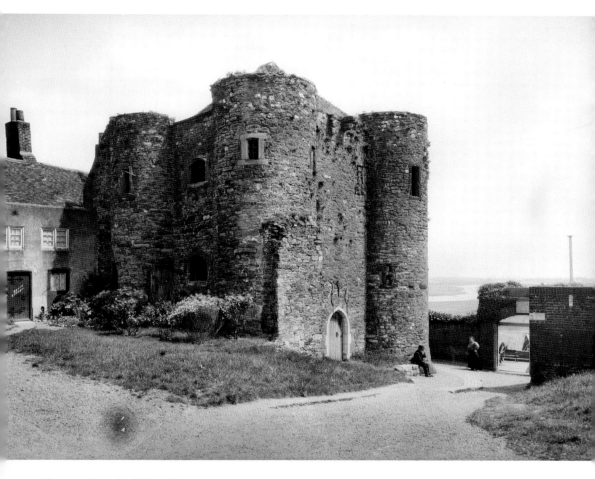

Above and overleaf: Ypres Tower and the Landgate, Rye
The town defences shown in these two images remind us firstly that Rye (and nearby Winchelsea) were particularly at risk from medieval and Tudor era French attacks. Secondly we are reminded that both were once easily accessible from the sea before the coast departed southwards and their coastal access silted up. Here we see the south front of the fourteenth-century Landgate and the Ypres Tower from the north-west, with the church behind the photographer. These photos, despite their lack of railway images or focus, were commissioned in 1909 by the London Midland and Scottish Railway, possibly for an advert for an excursion or holiday travel. (Historic England Archive)

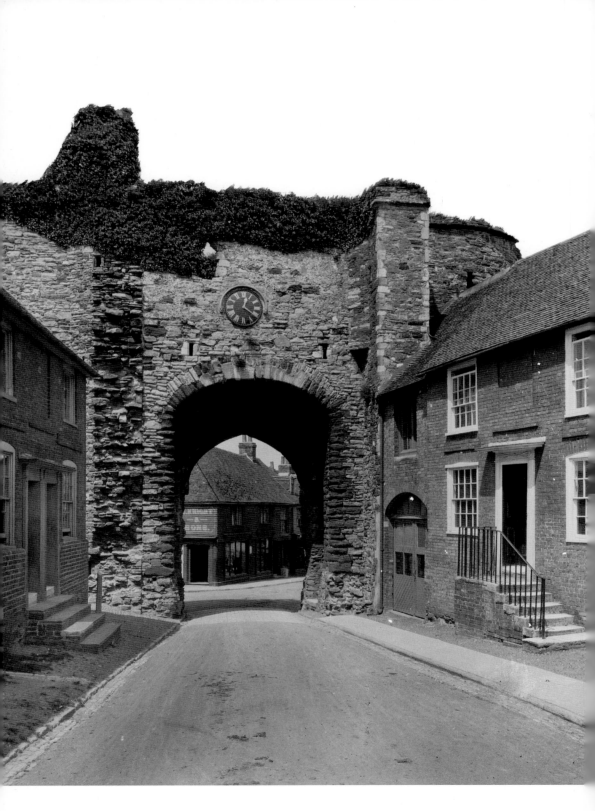

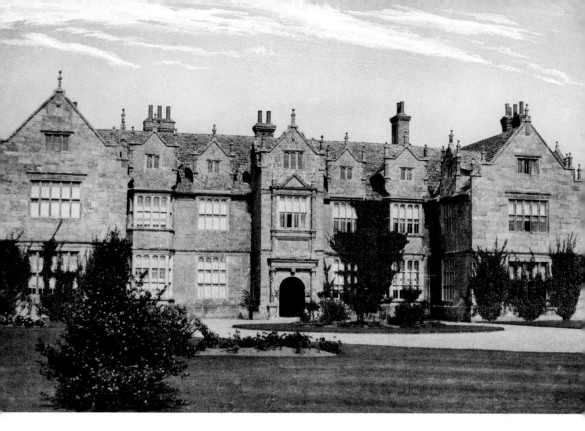

Above: Wakehurst (Place)
Another sumptuous building is Wakehurst Place and this view shows the south elevation, taken back in 1859. Originally built in 1571 by Sir Edward Culpeper around a central courtyard, the south range of the house was demolished before the end of the seventeenth century. The east and west wings were shortened considerably in 1848 and the south front of the north range was refaced. It was later restored in 1890 by Sir Aston Webb for Sir William Boord and in 2006 was used by Sir Kenneth Branagh for much of the filming of Shakespeare's *As You Like It*. Today the house and grounds are known as just 'Wakehurst'. (Historic England Archive)

Overleaf above: Arundel Castle
Although it seems the Saxons had some defences in Arundel, the Normans made sure that the castle built there replaced King Alfred's burh across the Arun at Burpham. The castle and town both suffered badly in the Civil War of the 1640s, when two sieges brought troops to Sussex and, as we see here in 1858, the castle still needed more conservation work and removal of (what seems a common nineteenth-century feature) incessant ivy spread. This view looks from the south-east past the tower on the west side of the curtain wall, up towards the keep of Arundel Castle. The tower in the curtain wall is located between the Norman keep and the Bevis Tower. (Historic England Archive)

Overleaf below: Brambletye House
As with Arundel, the Civil Wars brought Parliamentary troops to Sussex at Brambletye. It also brought destruction, Cromwell's troops destroying a house only built a decade before in 1631 by Sir Henry Compton. The resulting ruins can be visited via contact with English Heritage. (Historic England Archive)

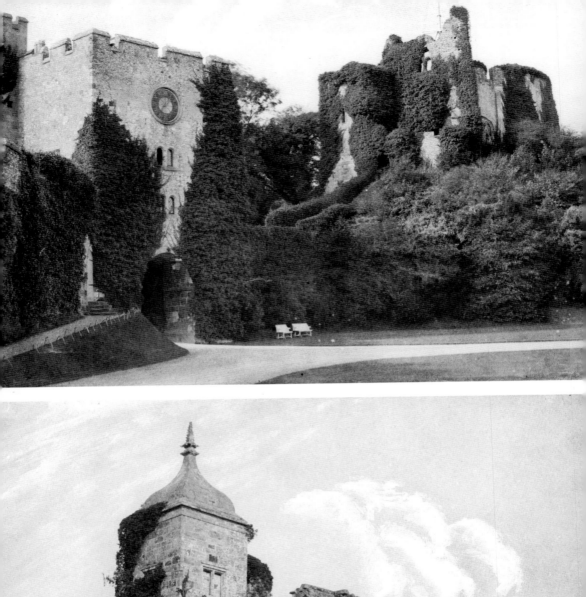
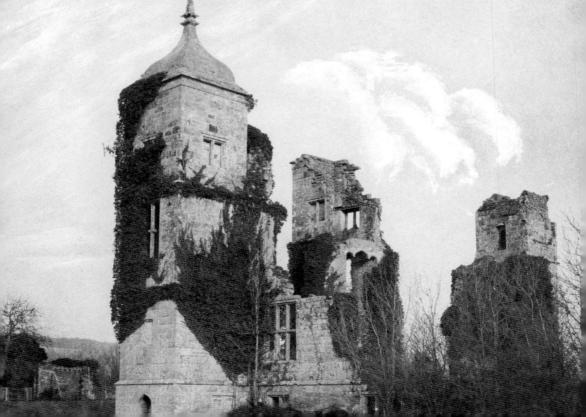

Streets and Buildings

This and the following chapters start at the west of the county and work eastwards.

Right and below:
Cowdray
Cowdray certainly was one of Sussex'a most beautiful buildings and the ruins, set in the valley of the Rother, still are, especially with a sunset behind the burned-down Tudor palace, which was once visited by Queen Elizabeth. Here we see the ruins of the Great Hall in the east range of Cowdray House before the ivy was cleared from it and the gatehouse later, in 1924. (Historic England Archive)

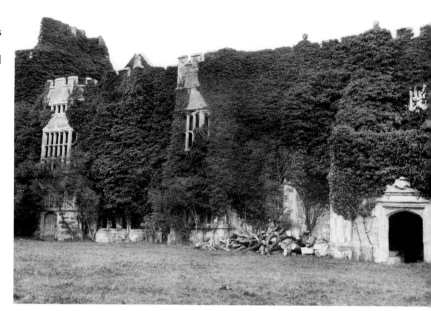

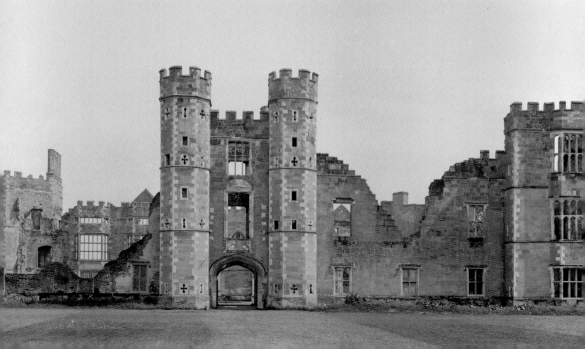

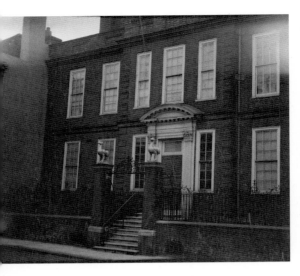

Pallant House, Chichester
The view here is of the front elevation of Pallant House, No. 9 on North Pallant. The house dates to 1712 and was built for Henry 'Lisbon' Peckham, a Chichester wine merchant, on the site of an old malthouse near the market. The house is known as the Dodo House because the gates are flanked on either side by a statue of a dodo. The stonemason carving the birds was apparently aiming for ostriches from the family crest but had evidently never seen what they looked like. The house is now part of the Pallant House Gallery, which is a leading art museum and gallery. Pallant House is considered to be one of the most important eighteenth-century town houses in England, and is a fine example of a Queen Anne town house that remains open to the public. (Historic England Archive)

Below and opposite: The Burlington Hotel, Worthing
Part of the 1860s development that started the growth of West Worthing, the Burlington was almost as luxurious as the adjacent Heene Terrace development, which, when built, was on the western extremity of the town. The hope for many years was that West Worthing would become to Worthing as Hove is to Brighton, or St Leonards was to Hastings. These 1913 images were likely taken for a sale. The interior of the Burlington is still recognisable today and this beautiful Victorian hotel at the junction of Marine Parade and Wordsworth Road still thankfully has the same name, although its winter garden is today a function room and nightclub. The buildings to the east of the hotel have changed architechtural styles from Victorian to art deco and are now twenty-first century while the Burlington survives in its original Victorian guise, although its bricks have since been given a stucco overcover and painted white and grey. (Historic England Archive)

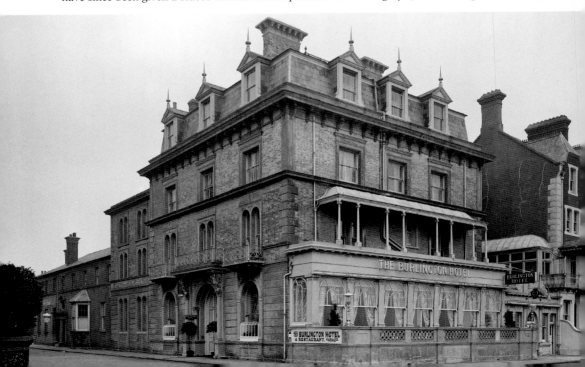

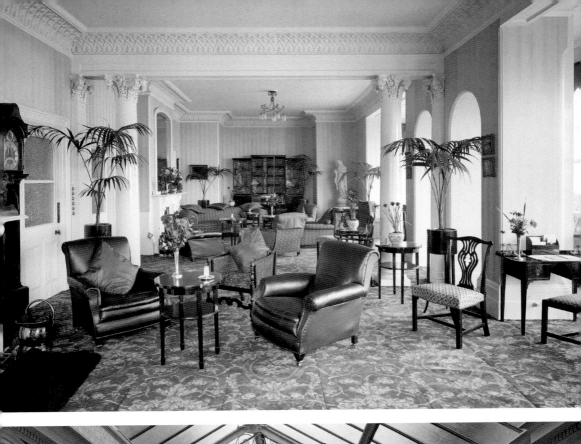
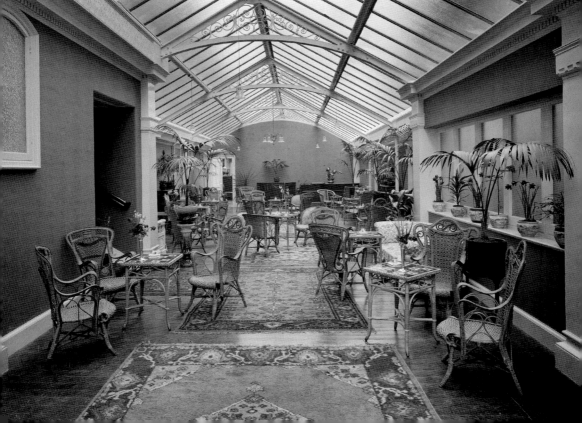

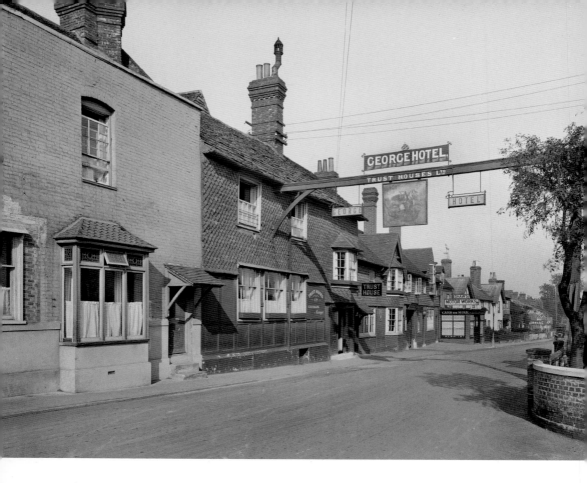

Above: The George, Crawley

Here we see the George Hotel, Crawley's most significant secular historical building, dating back to 1615 (possibly even 1450) and Grade II* listed since 1948. It is today part of the Ramada chain of hotels and so the George name is somewhat hidden, but it still has pride of place on the pedestrianised part of Crawley's High Street. This timber-framed inn had extensions added in the eighteenth and early nineteenth century. The photograph was taken for the owners, Trust Houses Ltd, which later became Trusthouse Forte. (Historic England Archive)

Opposite above: The Esplanade, Worthing

Here, under the caption of 'marina', although not in our modern sense of the word, we see the beach east of the Esplanade in East Worthing. Worthing's fishing fleet still moors on the beach here today. Much missed is the Esplanade, which later became part of the Esplanade Hotel and was probably demolished by the late 1960s. Oscar Wilde and his family stayed during the summer of 1894 and this is where he wrote his finest play, *The Importance of Being Earnest*. (Historic England Archive)

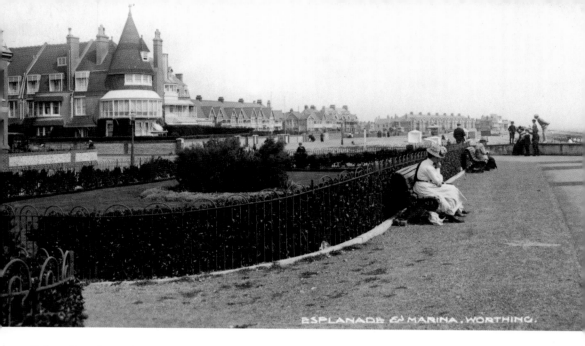

Below: Steyning

Steyning's Church Street is one of the prettiest streets in Sussex and little changed since its capture here on film around 1858, except for the occasional motor vehicle. The Brotherhood Hall on the left, dating from the fifteenth century, is today part of Steyning Grammar School's Church Street location, which first had pupils on this site in 1584. The Norfolk Arms, one of Sussex's hidden pubs that you could easily miss, is tucked just out of view on the right. (Historic England Archive)

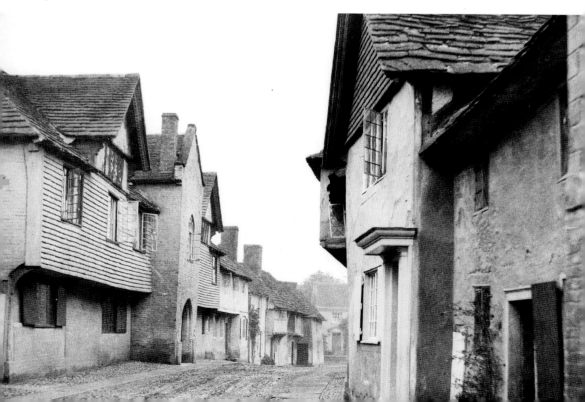

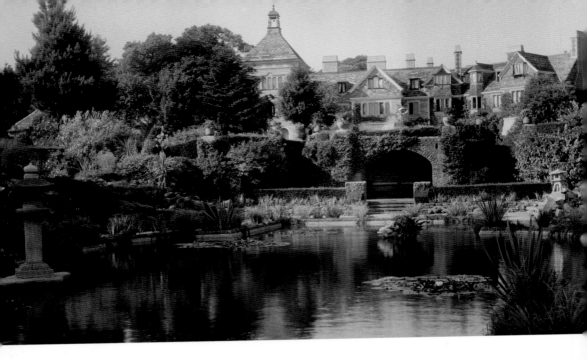

Sedgwick Park

Here we look north across the pond in the Water Garden at the Sedgwick Park, towards the neo-Tudor house, which was designed by Harold Peto and Sir Ernest George. The house and gardens are today private but are opened up for community and charity events, with tours possible of the ground floor of the house and gardens. The gardens, which featured in *Country Life* magazine no less than five times between 1901 and 1957, now have a nautical theme, with areas being named the White Sea, the Upper Deck, the Bulwarks, the Captain's Bridge and the Cabin. Alice Liddell, the young girl that Charles Dodgson (Lewis Carroll) took as his muse for *Alice in Wonderland*, spent her honeymoon at Sedgwick in 1880. An earlier version of the house was built on the site in 1608 and remodelled in the early eighteenth century by Sir John Bennet. To the west of the house is the site of a castle, dating probably from 1258 when the owner was given permission to crenellate. Today a few remains exist. (Historic England Archive)

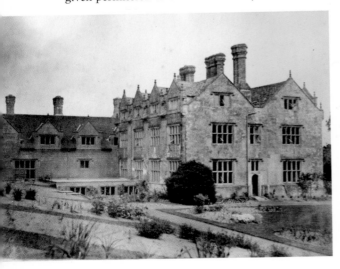

Gravetye Manor

Exterior view of Gravetye Manor from the north-west taken in 1886 or 1887, showing the first attempt to arrange the slope of the ground above the house. Gravetye was built in 1598 by Richard Infield, who wanted a love nest for he and his bride, Katherine Compton. The letters 'R & K' are still to be found in the stone above the main entrance door from the formal garden. Their portraits are also carved in oak in one of the bedrooms above the bed and visitors can experience this romantic place should they dine or stay today at what is now a wonderful hotel. (Historic England Archive)

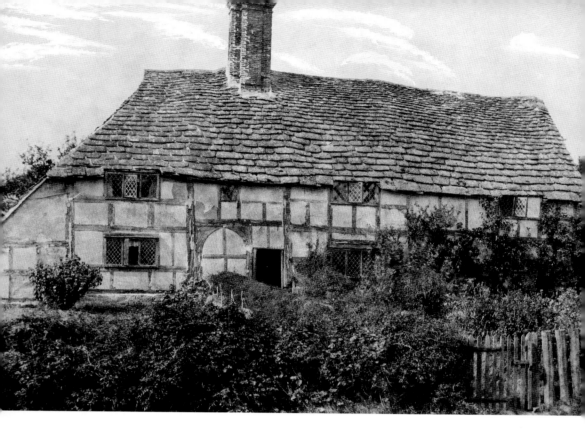

Priest House, West Hoathly

The front garden and south-east elevation of Priest House seen from North Lane. The fifteenth-century house was owned in turn by Henry VIII, Thomas Cromwell, Anne of Cleves, Mary I and Elizabeth I. It was restored in 1908 by Maurice Pocock and opened as a museum. It was presented to the Sussex Archaeological Society in 1935, which today is called Sussex Past, who still open it to the public. The only one of its kind open to the public, this beautiful fifteenth-century Wealden Hall house stands in a traditional cottage garden on the edge of the Ashdown Forest. It is now furnished with seventeenth- and eighteenth-century country furniture and domestic objects while the garden is planted with over 170 culinary, medicinal and household herbs. (Historic England Archive)

Bolebroke Castle

The gatehouse at Bolebroke Castle, seen from the south. This illustration appeared in *Mansions of Old Romance* by C. G. Harper. (Historic England Archive)

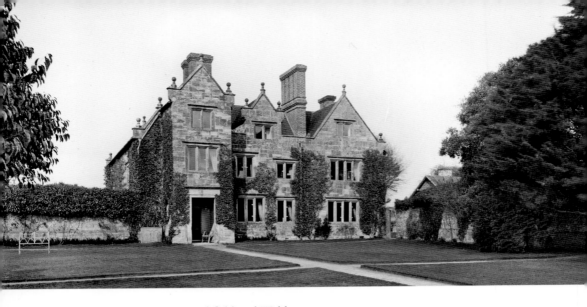

Possingworth Manor, Heathfield and Waldron
The newly built south front of Possingworth Manor was constructed in 1921 in a sympathetic architectural style to the rest of the seventeenth-century manor house. The estate was sold to Sir Humphrey Offley in 1635 following the Reformation and he built a manor house, although his son Thomas rebuilt the house in 1657. Only the north half of the building is original as the south half was demolished and rebuilt in 1921 and is presumably why this photograph was taken for builders George Trollope & Sons in that year. (Historic England Archive)

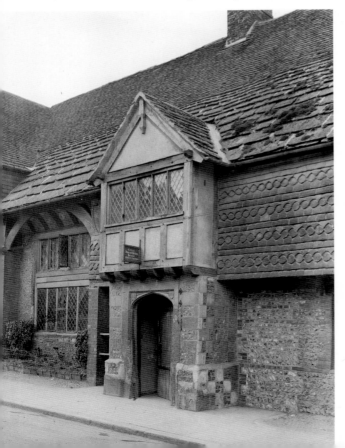

Anne of Cleves House, Southover, Lewes
Anne of Cleves House gets its name not because Henry VIII's wife lived there, but due to it being part of the generous divorce settlement the (now believed unfairly nicknamed) 'Flanders Mare' received from the king. This image was taken between 1915 and 1933 and the house is today a lively museum run by the Sussex Archaeological Society organisation and one of the many places in Lewes worth a visit. (Historic England Archive)

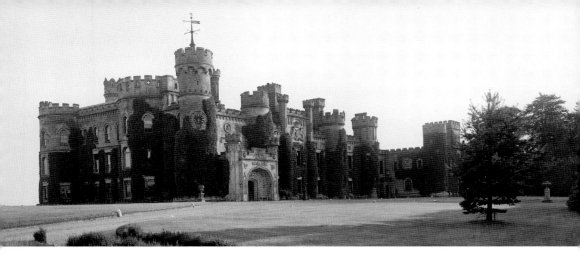

Above: Eridge Castle

Eridge Castle, which dated from the 1780s, was demolished in the 1930s and a new house, Eridge Park, was built in its place. (Historic England Archive)

Below: Michelham Priory

Michelham Priory is not only a beautiful set of buildings but the site is a catalogue of different eras of history, from its medieval moat dating back to the thirteenth century, the priory buildings and medieval gatehouse to its involvement in the Dissolution of the Monasteries. Today it is a museum for all the family that is also run by the Sussex Archaeological Society. It has a Tudor kitchen and a replica Bronze Age Roundhouse. The main (T-shaped) building dates partly from the thirteenth century and partly the sixteenth. This image was taken *c.* 1858 like many in the Historic England Archive. At this point it was owned by the Earl Amherst and his wife the Countess of Plymouth. (Historic England Archive)

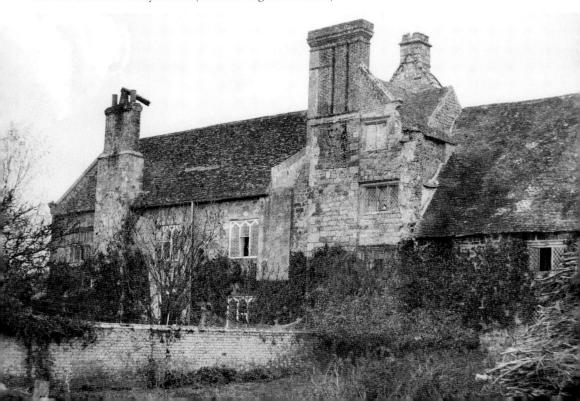

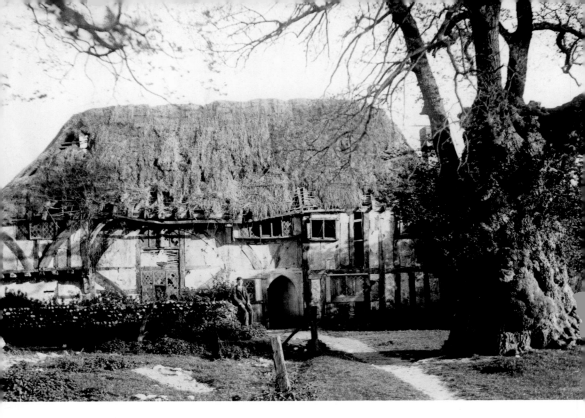

Above and below: Old Clergy House, The Tye, Alfriston, East Sussex
The fourteenth-century Old Clergy House was the first building, and second property, acquired by the National Trust, who restored it in 1898. These photos date from 1850–98 (above) and *c*. 1858 (below) before restoration had begun. (Historic England Archive)

Southover Hall, Burwash
With the National Trust's famous Bateman's estate dominating Burwash, it is easy to forget there was once an even bigger estate in the vicinity, Southover Hall, until the sale of the estate in 1944. Here we see the main front of the grand Victorian building from the north. The photograph was taken for Martin, Hood & Larkin (printers), and refers to the De Murrieta family who had lived at the hall but by April 1891 were living at Carlton House Terrace in Westminster. (Historic England Archive)

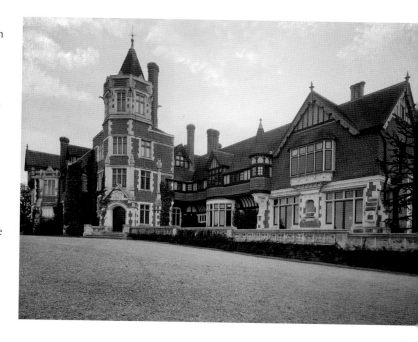

Leyswood

Leyswood was a particularly beautiful building no longer with us and unusual for Sussex as it was situated on a bed of rock. It was designed by Norman Shaw for Mr J. W. Temple and built in 1869. The vast majority of the building seen here from the north has been demolished and all that remains is the gatehouse and two sides of the courtyard. (Historic England Archive)

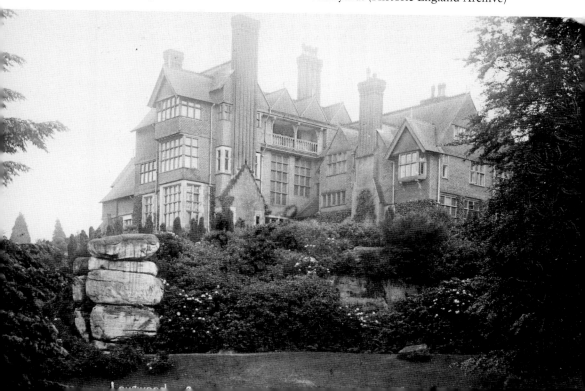

Above: Ardenrun Place
This country house of 1906, which later burnt down in 1933, was designed by architect Ernest Newton and modelled on William and Mary period architecture. The owner of the house was the banker Mr H. H. Konig. Here we see its circular drive from the north-east. (Historic England Archive)

Below: The Roberts Marine Mansions, Bexhill
A view from the north-west of the Roberts Marine Mansions, later the Marine Mansions Hotel, which was built in 1895. It was damaged by enemy action during the Second World War and was subsequently demolished. It stood on the corner of Devonshire Road and Devonshire Square. (Historic England Archive)

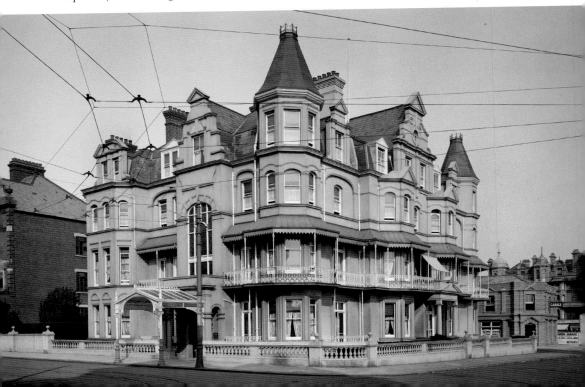

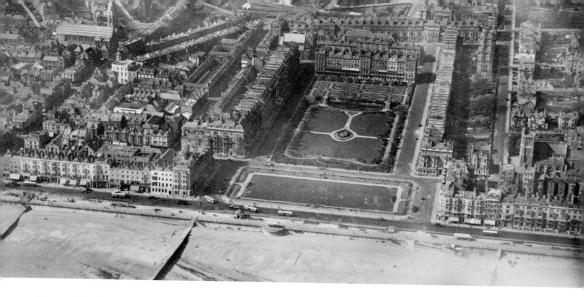

Above: Warrior Square, Hastings
The first of two sets of grand terraces in Hastings shown here was built between the 1850s and the 1870s. It takes its name from the Warrior field it was constructed on. The 17,300 square metre gardens had opened by 1852 and bands would play three times a week in the 1850s. Here we see it in 1929, around the same time as Devonshire Terrace. (© Historic England Archive. Aerofilms Collection)

Below: Devonshire Terrace, Hastings
Devonshire Terrace was the earlier site of Hastings' central cricket ground and even suffered a flood in 1913 after a gale. This returned it to something like its earlier medieval form when Priory Meadow (as it became) was the site of Hastings' harbour. The cricket ground in front of the terrace dated back to 1864. It is today the site of Priory Meadow shopping complex. (Historic England Archive)

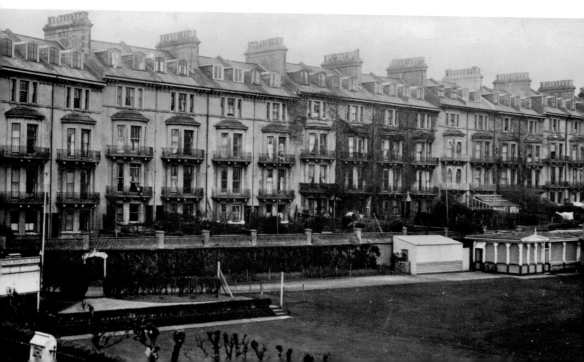

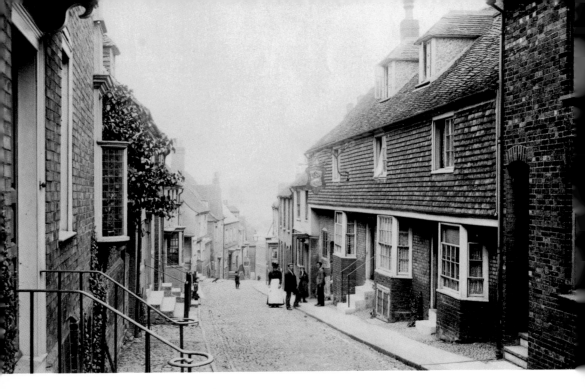

Above and below: Mermaid Street, Rye
One of the prettiest streets in Sussex, Mermaid Street (Church Street in Steyning and Lombard Street in Petworth provide some rivalry) still looks charming today. The fact that these buildings in this ancient street have survived creates the exquisite vista. The sea choosing to desert Rye, just as it did its partner town, Winchelsea, meant that dwindling economy led to less desire or money to invest in rebuilding or redesigning the frontages of buildings, compared with somewhere like Lewes. Yet it also left a much more ancient reminder of the past. The street takes its name from the famous Mermaid Inn, which also features in the Entertainment and Leisure chapter. (Historic England Archive; Author's collection)

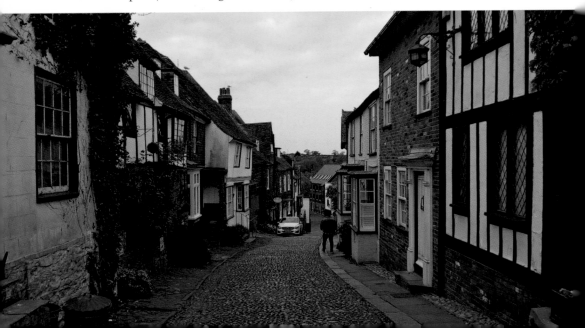

Public Buildings

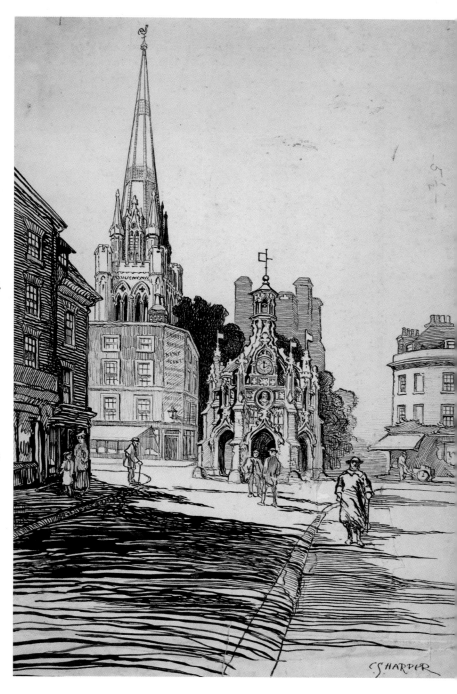

Chichester Market Cross and Cathedral
A view from the east of the Market Cross, with the spire of Chichester Cathedral and the bell tower in the background. The Market Cross, despite its grandeur, was nonetheless a public building built on the orders of Bishop Storey, who when he wasn't involved in the religious executions of the Tudor era decreed that the poor of Chichester should have a market cross to sell their wares under. The cross trumps the only other example in Sussex; Alfriston's rather spindly and reduced market cross. It was, unbelievably, surrounded by traffic until the pedestrianisation of Chichester's city centre. (Historic England Archive)

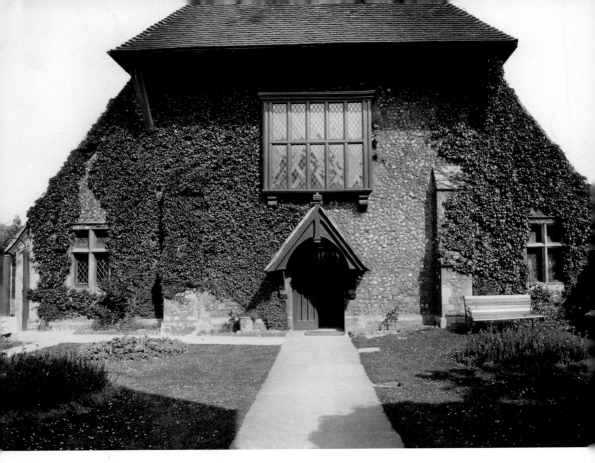

Above: St Richard's Hospital, Chichester
This very unusual-looking building is listed as 'Almshouse' in the archive. (Historic England Archive)

Opposite above: Petworth Station
Sussex's rural hinterland was badly hit by Dr Beeching's axe in the 1960s. Here we see Petworth station, which closed in 1966. The location of the station is today 2 miles south of the town and this view is from the south-east. If the station still existed, with electrified lines and the speed of trains today, the man nearest to us would be admonished for risking his life. Today the station buildings and former train carriages form a friendly bed and breakfast. (Historic England Archive)

Opposite below: The George & Dragon, Houghton
Parts of The George & Dragon date back to 1276. Current owners Gavin and Carole Welcome have been in charge since 2009 and have restored the fortunes of this ancient inn, which was once visited by Charles II (as he would become) on his escape route from Parliamentary forces on his way to France. The inn is much busier today than it was in 2009, and the road that narrowly passes the George here is equally much busier today than it was at the start of the twentieth century, when Charles Cunningham was landlord. (Historic England Archive)

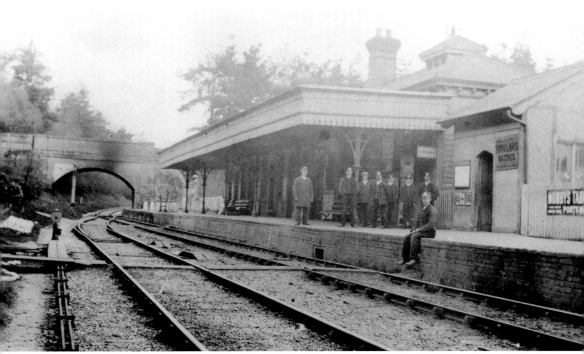

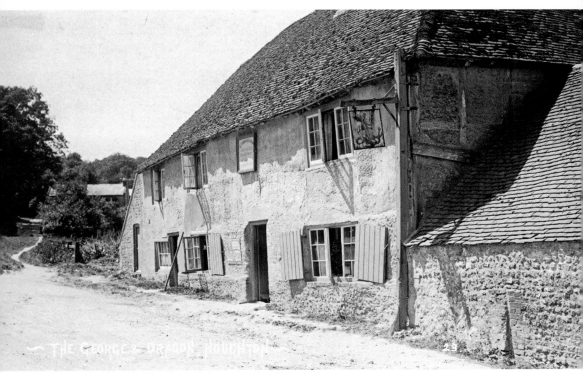

THE GEORGE & DRAGON HOUGHTON

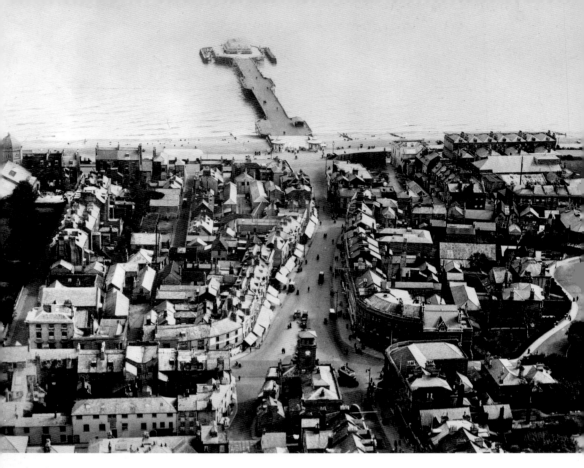

Above: South Street and the Pier, Worthing
The much-missed Worthing Town Hall at the top of South Street. Note how empty the pier is.
(© Historic England Archive. Aerofilms Collection)

Opposite: South Street, Worthing
Moving down to street level, we see the top of South Street and Worthing Pier in the distance. The architecturally impressive Waterloo House to the left of the picture has been replaced by Debenhams' massive 1920s department store building. A man, probably a sign painter, is standing by two ladders in front of Waterloo House. The archive dates this as between 1850 and 1920 but the lack of cars, inclusion of the 1862-built pier and name 'Berlin' on what is now the Nationwide Building Society at the north end of the Royal Arcade suggests that it was taken before 1914. Although hard to see, the apparent lack of the 'lemon-squeezer' kiosks at the entrance to the pier from 1884 and the pre-1890 look of the street help to narrow the time frame down further to around 1880. The second photo, after the building of the Royal Arcade, is dated 1922, and shows how the same view has changed. (Historic England Archive)

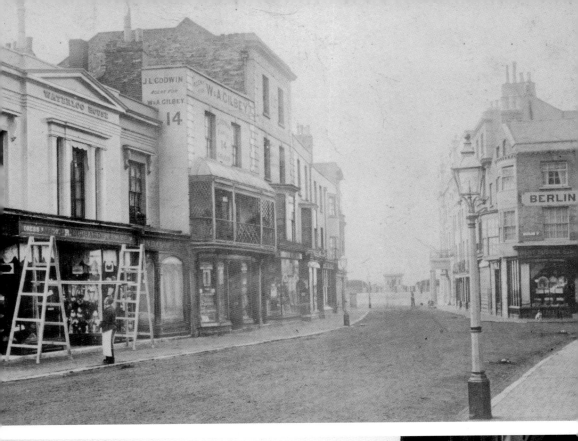

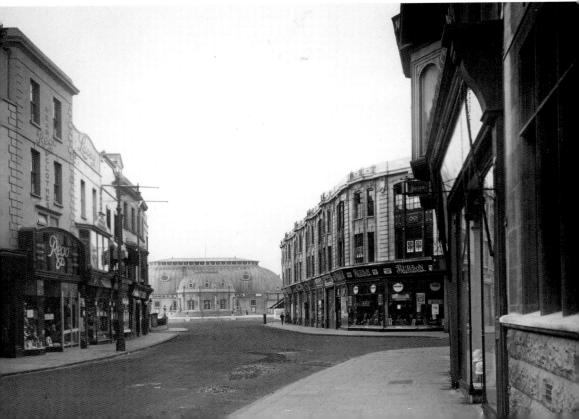

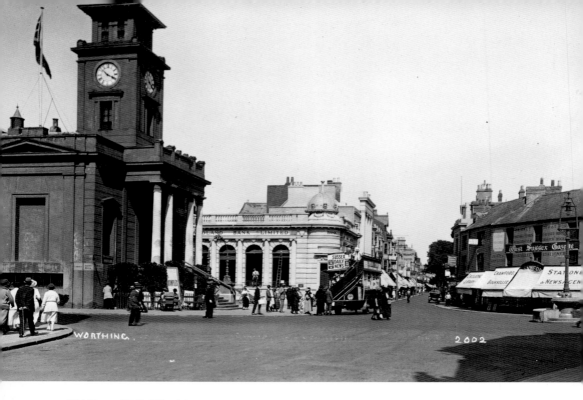

Old Town Hall, Worthing

Turning 90 degrees east and moving northwards slightly, we see Worthing's much-missed old Town Hall on the left of the picture, located on the site of what is today the front concourse and steps of the Guildbourne Shopping Centre. Constructed in 1835, this handsome building saw its end in 1966. By this time it had been made obsolete by the new 1930s Town Hall in Chapel Road and was seen as too small to be fit for purpose. The original Town Hall comprised police cells, a courthouse, bank, garage for the town's fire engine and a hall that suffragettes had held talks at. Worthing's election results were announced from the building's steps. (Historic England Archive)

St Mary's Church, Sompting
St Mary's Church, seen from the south, is remarkable as it is the only church of its type left in the county with its Saxon 'Rhenish helm' spire. (Historic England Archive)

St Michael's Church, Lewes

Rodolph Stawell, author of *Motoring In Sussex & Kent*, wrote that 'At Lewes all Sussex is ours to choose from'. From all Lewes's churches we have selected St Michael's Church, not just because it is Lewes's parish church, which was restored in 1885, but because it is one of the three Sussex churches with Norman round towers (the others are Piddinghoe and Southease). It also has a memorial to Sir Nicholas Pelham of Laughton, reminding us of his vital role in repulsing the French attack on Sussex that landed at Seaford in 1545. He was not a major Sussex landowner but did purchase what is today the White Hart as his townhouse in Lewes, not far from St Michael's. (Historic England Archive)

St John the Baptist's Church, Southover, Lewes

St John's is an important public building for several reasons. As a church it is of course important to its parishioners and wider community. It is also part of the site of the once massive Lewes Priory and was the site of the priory's hospital. Most of all though, when the Brighton–Lewes railway line was being excavated in the 1840s through the priory site, the tomb of Gundrada was discovered, who is believed to be William the Conqueror's daughter. She is now interred in her own chapel within the church and visits are possible. (Historic England Archive)

The Old Manor House, Crowhurst
A view looking south past the west tower of St George's Church towards the ruins of the Old Manor House. The Old Manor House was originally built by Walter de Scotney in 1250. The ruins consist largely of a gable end with a large pointed window. (Historic England Archive)

Middle House Hotel, Mayfield
The Middle House is a Grade I public building today and a wonderful example of Elizabethan architecture, featuring highly decorative timber framing. The house was originally built in 1575 for the financier Sir Thomas Gresham, keeper of the Privy Purse to Her Majesty Elizabeth I. It remained as a private residence until the late 1920s and is now a hotel. Its large, ornate, wooden, carved fireplace in the lounge area is by Grinling Gibbons, the master craftsman who is responsible for so much fine work within St Paul's Cathedral and the famous room bearing his name at Petworth House. Records show that the fireplace originally came from the Royal College of Physicians in London. The view here is looking west across the front of Middle House and the houses on the south side of the High Street. (Historic England Archive)

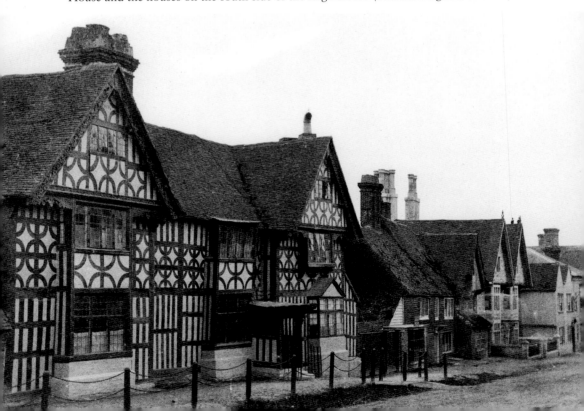

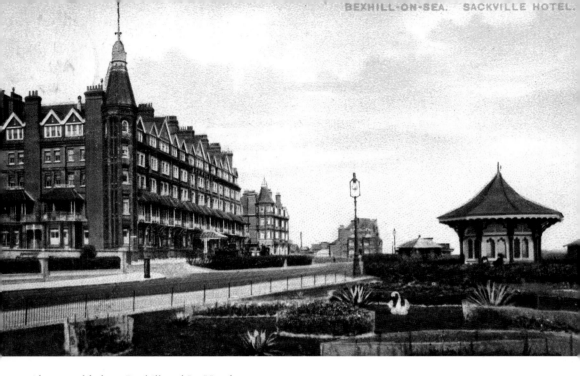

Above and below: Bexhill and Its Hotel

Bexhill was a late developer as far as Sussex's seaside resorts go but made up for it with both the Sackville here, which opened in 1890, and Bexhill's own Metropole Hotel. It was built for the 7th Earl De La Warr and originally included a house for the use of his family. In 1897 the Sackville Hotel was sold to Frederick Hotels, owners of the Brighton Metropole, who ran the hotel for over sixty years. The Metropole suffered bombing in the Second World War whereas the Sackville was converted into retirement apartments in 1963. The static nature of the swan here in the seafront garden suggests it is an artificial one. An earlier black and white version of this postcard also exists in the Historic England Archive dated from 1895 to 1904. The image below is of the Yacht Pond at Bexhill. (Historic England Archive)

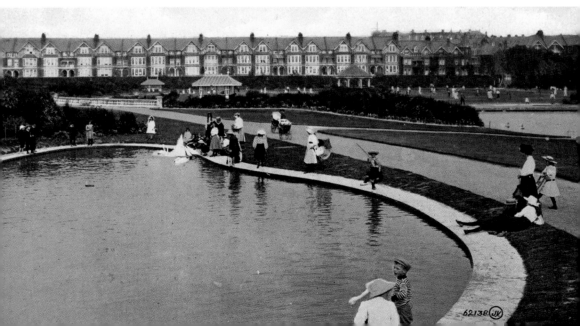

Entertainment and Leisure

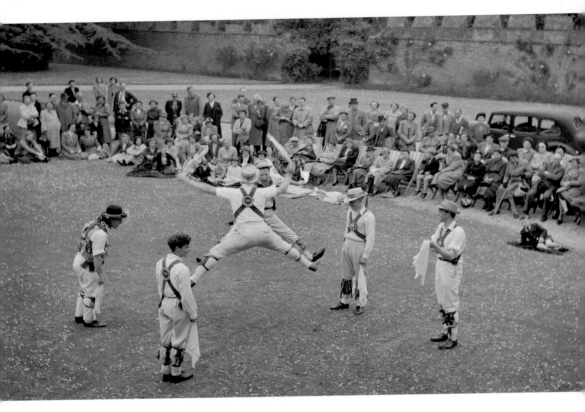

Above: Morris Men, Bishop's Palace, Chichester

Morris men may seem as English as things get but the name most likely came from 'Moorish men'; in the 1400s, when the dance first seems to have come to England, the phrase was used for anything foreign, much as 'Egyptian' also was later on. They can be seen performing traditional folk dance, accompanied by music, on Boxing Day and other occasions across the county. Here we see two Morris men defying gravity while spectators watch on in the walled garden of the Bishop's Palace in Chichester. The archive suggests the image is *c*. 1960 but the car suggests either this happened earlier or one of the spectators or Morris men had looked after their car well. (© Historic England Archive)

Opposite above: Harbour Park Entertainment Centre, Littlehampton

He we see the area where the Harbour Park Entertainment Centre is. Billy Butlin first opened a theme park here in 1932 where the East Bank Fort and windmill had been. As with most similar parks, it closed during the war years between 1941 and 1945, suffering bomb damage and its buildings being used for wartime storage. After repairs, Butlin would eventually sell the park to the Rank Organisation, and then in 1977 it became Smart's Amusement Park after its sale to Billy Smart. It was Smart who gave the park its current name and you can still see a bronze statue of him gazing over the park. (© Historic England Archive. Aerofilms Collection)

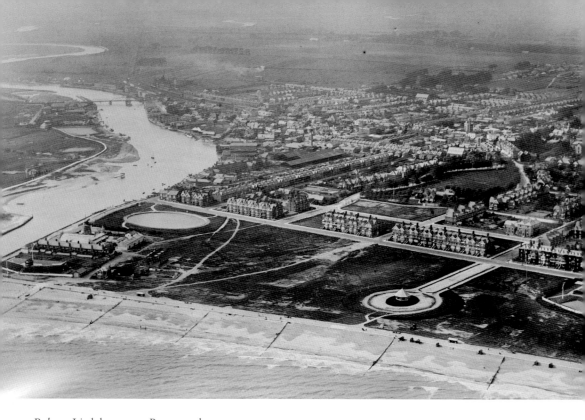

Below: Littlehampton Promenade
Zooming into street level to the same area shown above, we see the people walking along Littlehampton promenade at a time dated between 1890 and 1910. (Historic England Archive)

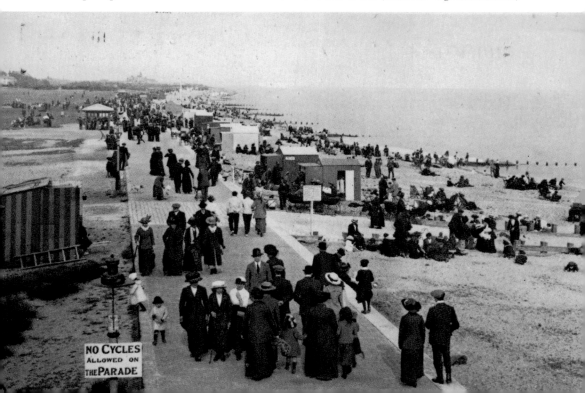

NO CYCLES
ALLOWED ON
THE PARADE

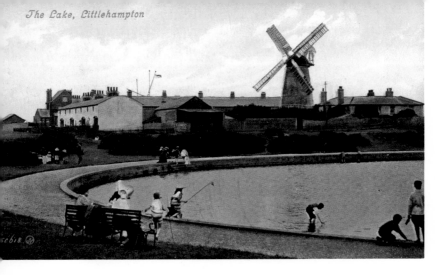

The Lake, Littlehampton

Littlehampton Lake
This is the artificial lake shown from the air in the picture before last. The windmill is remembered today in the names of the local Windmill Theatre and Harvester pub. (Historic England Archive)

Below and opposite above: The Brunswick Hotel, Worthing
Seemingly Worthing's most renamed pub, the Brunswick has also been the Aintree, The Bay and has now settled on the Brunswick & Thorn, taking the American custom of naming corners of streets after the streets that meet there. Thorn Road takes its name in turn from the building firm that constructed the road. It is today a bistro and café/wine bar but the building as we see it is one of Worthing's most historic taverns. The shop to the left of the pub, two doors down, was the King & Queen – a beer shop (or 'bottle and jug') according to the Worthing Pubs website – which opened when the Brunswick became a hotel. The image below, dated 1910–25, was 'before rebuilding' according to a description on this lantern slide. The second one is after the rebuilding by the architect Ernest Emerson FRIBA for the brewery William Younger & Co. Ltd. (Historic England Archive)

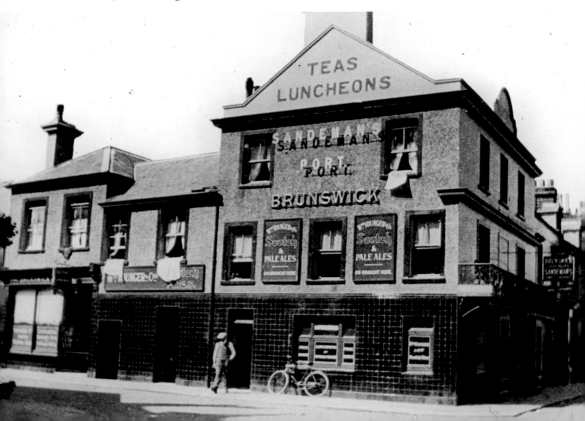

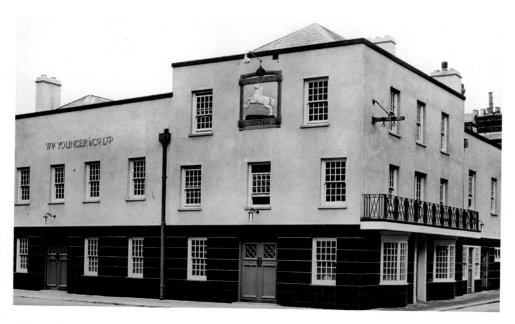

Below: The Bandstand, Worthing

Replaced with a swimming pool and later on the lido complex (arguably Worthing's West Pier and the country's smallest), here we see Worthing's first use of this site for its 'birdcage' bandstand. It was seen as vital that each seaside resort had an area for live outdoor music until the Second World War when overseas holidays, LP records and television changed people's habits. Before that happened, the site would be expanded over the sea to its current size with space for over 2,000 deckchairs in 1925. Between 1959 and 1967 half of the site became an unheated open-air swimming pool, which is why the site is still called 'The Lido'. Today the promenade by the site has recently been used for the Walkers Crisps commercial with Gary Lineker and even more recently for filming the 2019 film *Stan and Ollie* starring Steve Coogan. (Historic England Archive)

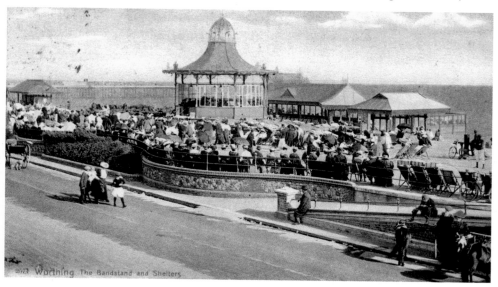

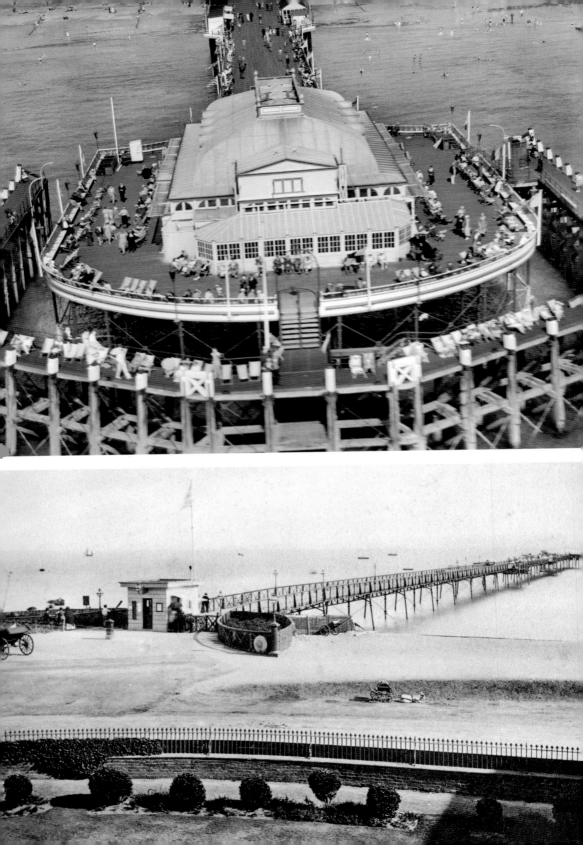

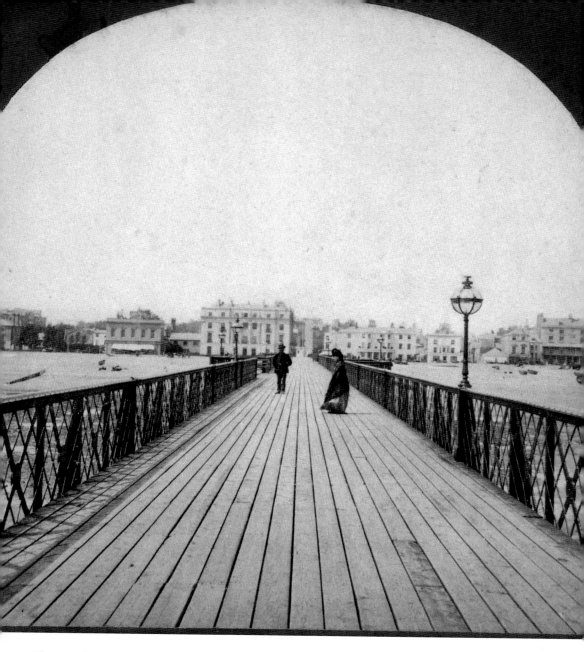

Above and opposite: Worthing Pier

By today's standards early incarnations of Sussex's piers would hardly justify the prefix 'pleasure' being added to them. The sole pleasure involved was the novel experience then of promenading above water – without the movements involved with ship travel. The idea of amusements (in the modern sense) on a pier would not exist until the pre-war years. This view (opposite below) is from the land end near the south end of Bath Place and appears soon after the pier's opening in 1862, with its first, very narrow incarnation. The garden in the picture appears to be that of the Royal Sea House Hotel opposite above. The image shows Worthing Pier in the same year, just before the original southern pavilion here burnt down. (Historic England Archive; © Historic England Archive. Aerofilms Collection)

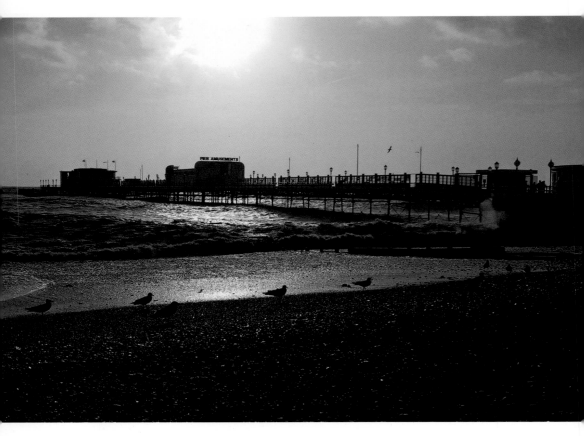

Above: Present-day Worthing Pier
Worthing Pier survived the fires of 1913 and 1933 as well as its dismemberment of 1939 to stop Nazi landing forces using it as a jetty to aid an invasion of Britain. However, perhaps the greatest insult it has suffered was thankfully only acted out for television: in 1998 its huge carbon fibre mascot 'Wetfish Willie', who 'welcomes you to Worthing', was stolen by Neil Morrissey and Martin Clunes in the guise of their *Men Behaving Badly* characters Gary and Tony on a drunken night out. Willie was created especially for the episode to be stolen but spent many years afterwards in storage in Worthing. Series creator and writer Simon Nye based the episode in Worthing because he knew Sussex, having grown up in the county and having relatives in the town. (Author's collection)

Above and below: Tennis Court and Orangery, Crabbet Park, Worth

Moving inland to a place of sporting leisure, Crabbet Park was well known for the Crabbet Club in the early years of the twentieth century, of which all the leading politicians and other prominent people were members. The architect of this building was Neville Stephen Lytton, who resided on the Crabbet Park estate and competed in the 1908 Summer Olympics, winning the bronze medal in the real tennis competition. Joseph Bickley, the well-known builder of tennis courts, was employed to build the luxurious building, which even boasted an inglenook fireplace. The exterior of the tennis courts at Crabbet Park here is viewed from the south-east. The interior photo is a group portrait that includes Neville Stephen Lytton and his wife Judith Blunt Lytton, who was the 16th Baroness Wentworth. (Historic England Archive)

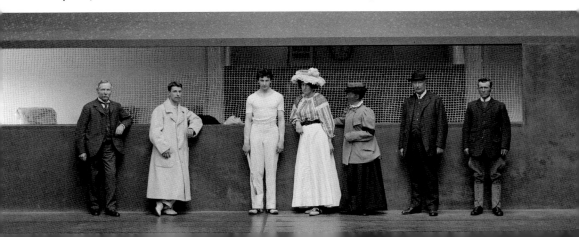

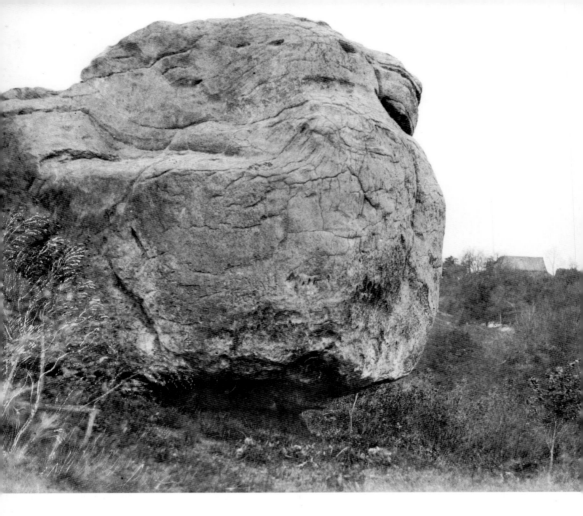

Big-Upon-Little Rock, West Hoathly

The Big-Upon-Little Rock got its name from the way water had eroded the bottom half of this limestone block from the neighbouring cliff. It provided endless entertainment from the 1600s and shows that the world of graffiti and tagging is nothing new. In the seventeenth century this stone attracted visitors in large numbers who carved their names wherever there was space on the rock so that, by the late eighteenth century, we learn that Big-Upon-Little was 'covered with multitudes of names and initials of all dates'. The more daring could jump from the nearby cliff onto the rock to write their names higher up. (Historic England Archive)

The Star Inn, Alfriston
Inns most definitely are places of entertainment and leisure and this is one of Sussex's most cherished ones. The Star Inn, along with its neighbour the George, is the pride of this much-visited, picturesque Sussex village. The former is over 800 years old, and here we see the inn before its conservation, which revealed its fantastic close timber work. Two men and two boys stand by the entrance to the inn. (Historic England Archive)

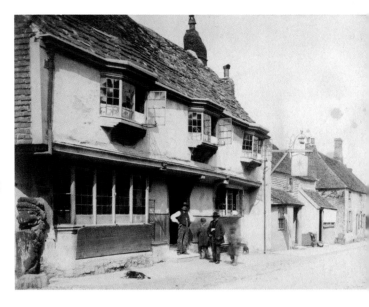

The Witches' Circus, Wannock
General view showing the entrance to Witches' Circus. This was a popular tearoom in the 1950s and 1960s visited especially by people from Eastbourne. Wannock nestles below the Downs between Polegate and Jevington. (Historic England Archive)

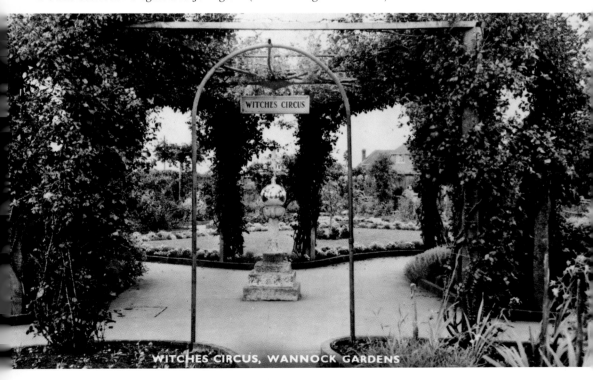

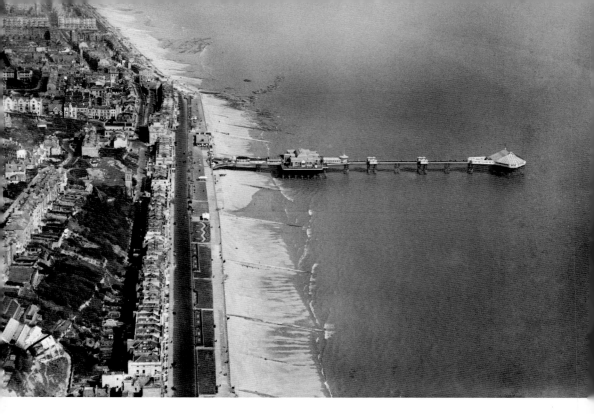

Above, below and opposite: The Palace Pier, St Leonards
Hastings once had two piers. St Leonards Pier was lost in 1951 but here we see the interior of the North Pavilion's theatre in an image commissioned by John Henry Gardner, who purchased the pier in 1917. The Palace Pier at St Leonards was built between 1881 and 1891 at a cost of £30,000 and measured 960 feet in length. It was designed by R. St George-Moore, with the North Pavilion designed by F. H. Humphries. The pier was demolished in 1951 after sustaining damage in rough weather. The other images are of the pier's elegant bar and roller-skating rink, as well as a shot of the now lost pier from its sea end. (© Historic England Archive. Aerofilms Collection; Historic England Archive)

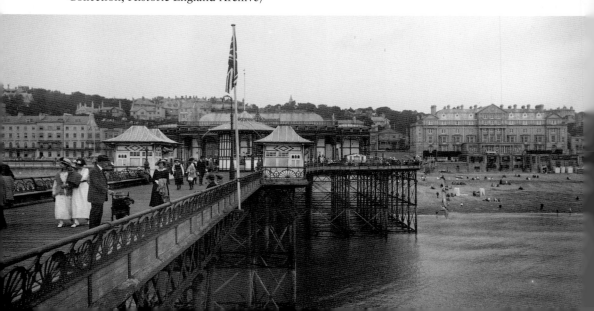

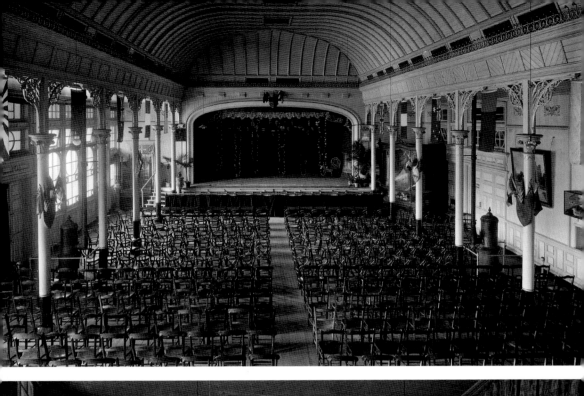

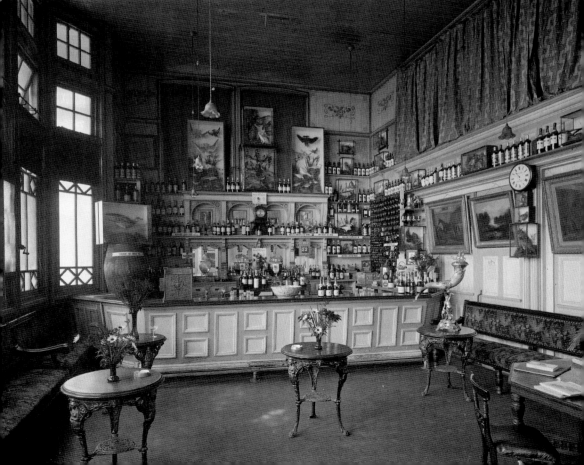

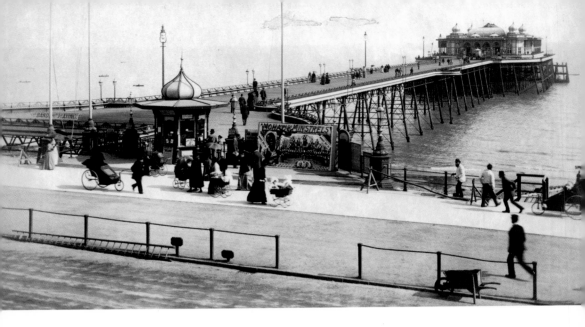

Above and below: Hastings Pier
Built in 1872, Hastings Pier was a popular music venue in the 1960s. It was damaged by a storm in 1990, but has recently been restored, reopening in 2016. (© Historic England Archive. Aerofilms Collection; Historic England Archive)

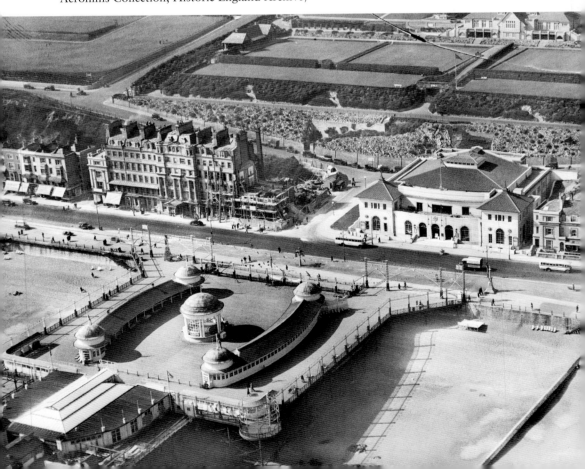

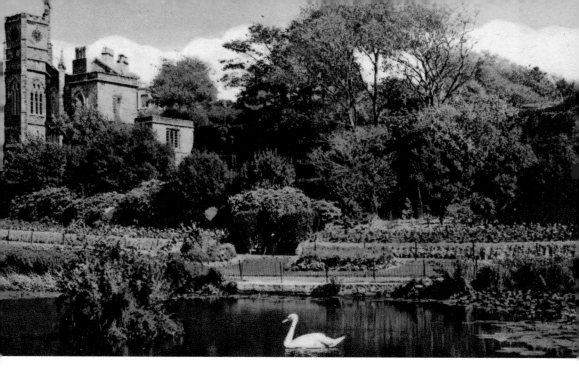

Above and below: Victoria Gardens, St Leonards, and Alexandra Park, Hastings
The two images here, both from 1900 to 1920, show the green sides of Hastings and St Leonards. Victoria Gardens opened in 1828 and Decimus Burton, the town's creator, wanted a green heart for his new development shadowed by grand villas, as Brighton hoped for with Queen's Park. Originally private until the 1880s, the gardens have been visited by Queen Victoria before her reign, and the gardens also have witnessed several literary visitors including the writer Rider Haggard (of *King Solomon's Mines* and *She* fame), who lived in the North Lodge, and even Rudyard Kipling. The more easterly Alexandra Park in Hastings takes its name from the Princess of Wales (Princess Alexandra) who, along with her husband, the future Edward VII, formally opened the park on 26 June 1882. (Historic England Archive)

LAKE ALEXANDRA PARK, HASTINGS

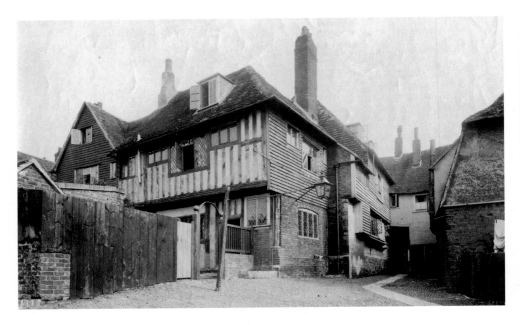

Above and below: The Mermaid Inn, Rye

Here we see the rear of what is known nationally as one of Britain's most haunted pubs. Built in 1420, the cellars date to 1156. Today the alleyway to the right of the inn is a narrow alley just about passable by cars willing to take the sharp turn to access the car park that the land behind the building has since become. The rear of the building hosts the inn's cosy bar. The image below is of Mermaid Street and the front of the inn in 1924. (Historic England Archive)

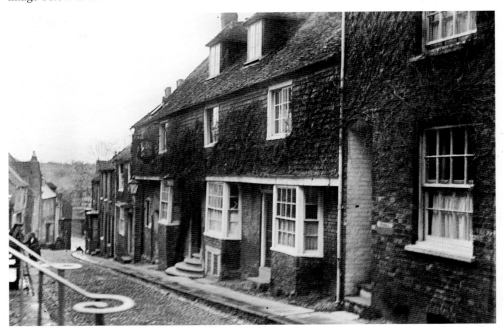

Education

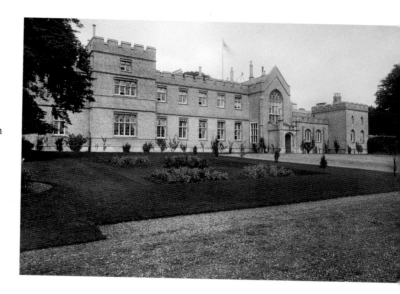

West Dean College
Entrance front at West Dean Park as it was in the 1890s, seen from the south-west. The photograph was taken for William Dodge James, who acquired the house in 1892 to show work carried out by architects Ernest George and Harold Peto between 1892 and 1895. (Historic England Archive)

The Beach Hotel, Worthing
Today the Beach Residence and Hotel, it was formerly the modernist/art deco-style Beach Hotel and here it is in its first guise as a terrace of Victorian town houses. Emily Wilding Davison taught here when the terrace included a school. (© Historic England Archive. Aerofilms Collection)

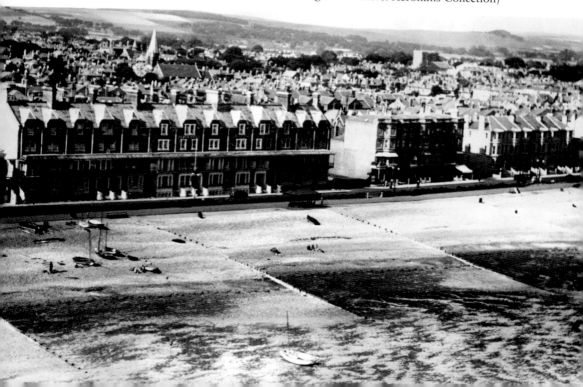

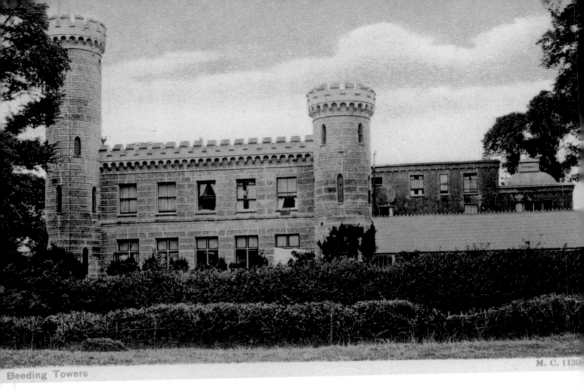

Beeding Towers

The Towers, Upper Beeding

The Towers School is also the home of the Convent of the Sisters of the Blessed Sacrament, who originated from France in the 1670s. In 1903, escaping anti-religious sentiment in France, they made their home in Upper Beeding in a building designed by architect George Smith for Jasper Wheeler in 1883. Wheeler's financial problems meant he ended up selling the house to Smith. Sister Mary Agnes, who had leased the house before her fellow French sisters moved in, purchased The Towers by 1908 off its then owner, Arthur Payne, and it has remained the sisters' home ever since, as well as becoming a girls' school. The 80-foot main tower seen here was found to be unstable and so was demolished soon after the time this picture was taken in 1911. Another was totally demolished and the remaining towers were given spires. The hunting lodge, as The Towers had been when leased by Mrs Wynch, has since gained a third floor, needed as the school roll increased. The student body has even included two princesses, one of which was Princess Charlotte of Monaco. The school today also accepts boys up to the age of eleven and tours of this unique building are available. (Picture courtesy of Antony Edmonds)

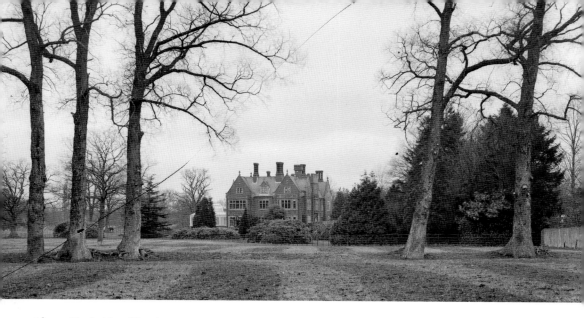

Above: Tanbridge, Horsham

This neo-Elizabethan house was built in 1887 by Thomas Oliver, who made his money in railways. After his death in 1920 it was sold, later becoming a girls' high school called Tanbridge House, which is today a co-educational comprehensive school. The photograph is one of a batch taken for builders and decorators George Trollope & Sons. This view of Tanbridge was taken from the south in the grounds in march 1921. (Historic England Archive)

Below: Cottesmore School, Crawley

Looking across the lawn towards the east front of Buchan Hill in 1887. It was the second building on the site, the original house being built in the early 1800s by Hon. Thomas Erskine (later Lord Chancellor). The second Buchan Hill was built four years before this photo was taken by Philip Feril Renault Saillard, who made his money in ostrich feathers. On Saillard's death it was bought by Upland House School. One of the masters was Michael Rogerson, who left to run Cottesmore School in Hove and after the Pearl Assurance Company (who had been there during the war) moved out in 1946 Michael Rogerson returned and purchased it for Cottesmore. The school remains there today. (Historic England Archive)

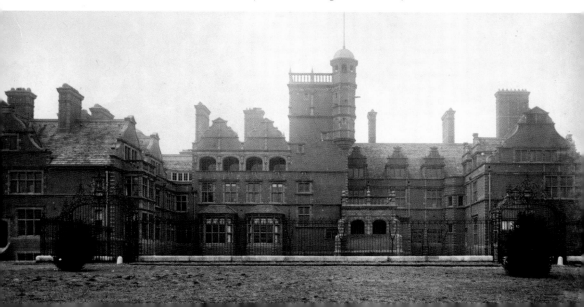

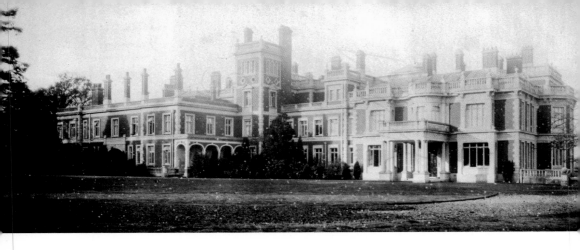

Above and below: Milton Mount School, Crawley

This view is from the north-east of the principal entrance front of Worth Park. The Worth Park estate was purchased by Sir Joseph Montefiore in 1850. Worth Park was built in 1884–87 by the owner Sir Francis Abraham Montefiore following the death of his father in 1880. This image was taken on his request. The estate was broken up and sold in 1915 and in the 1920s the house became a boarding school, Milton Mount College, which was founded in 1871 for the education of the daughters of Congregational ministers in Milton, near Gravesend, Kent. The school evacuated pupils in the Second World War and closed in its final Sussex location in 1960. The building was sadly demolished in 1963, but the grounds remain much as they were as Milton Mount Gardens. Milton Mount Park Primary School still exists nearby. The grounds became a public park. (Historic England Archive)

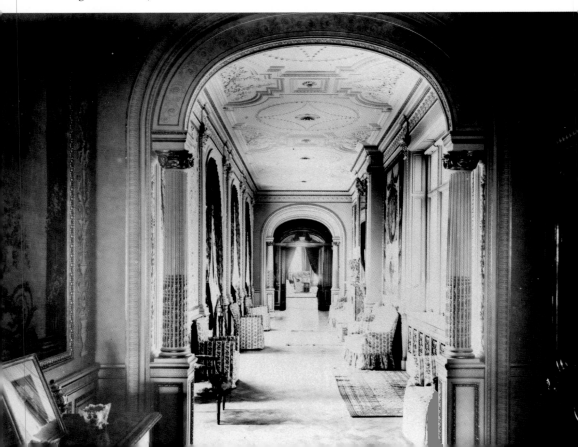

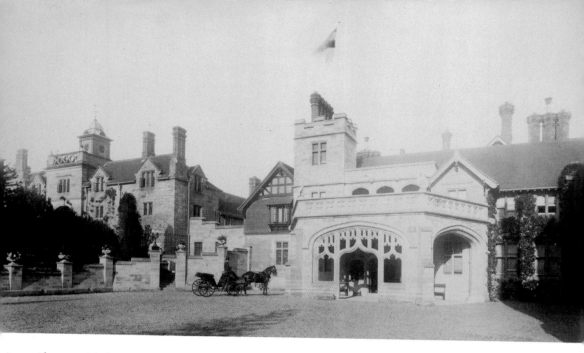

Above and below: Worth School, Turners Hill

Like The Towers mentioned earlier, another Catholic school features here that started life as a private house, called Paddockhurst in Turners Hill, West Sussex. Paddockhurst was built in 1865. In 1881, it was bought by Robert Whitehead, engineer and inventor, who added a new wing to the building using the architect Arthur Cawston. Here we see the porte cochère and new wing at Paddockhurst, with a horse-drawn carriage parked outside, three years after that purchase – in 1884, presumably when the building work was completed. The building later became Worth Abbey School and is known as just Worth School today. (Historic England Archive)

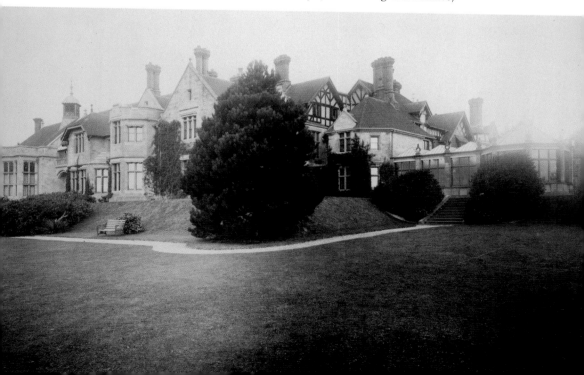

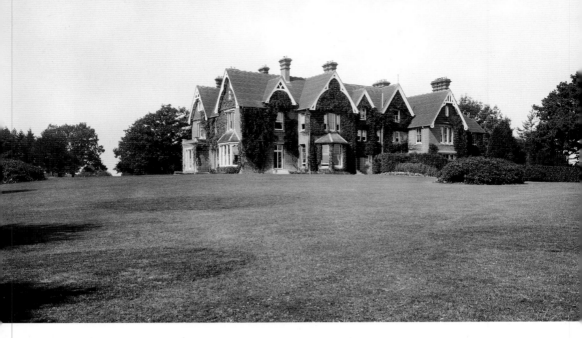

Above: Great Walstead House, East Mascalls Lane, Lindfield
This photograph was commissioned by Knight, Frank and Rutley Ltd, property valuers and auctioneers founded in 1896, and was probably taken ahead of the house's sale or letting. Great Walstead House was converted into a preparatory school in 1927, and it still exists as Great Walstead School today, with the original house incorporated into a larger complex of school buildings. (Historic England Archive)

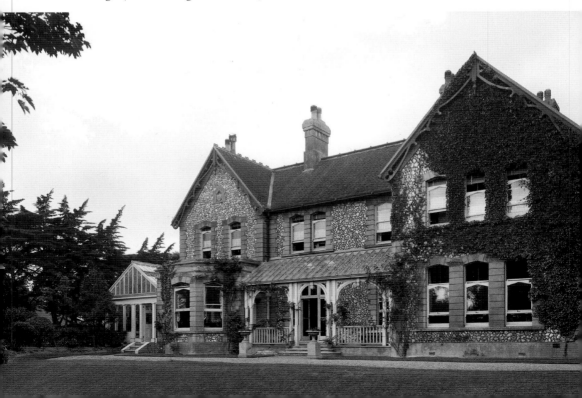

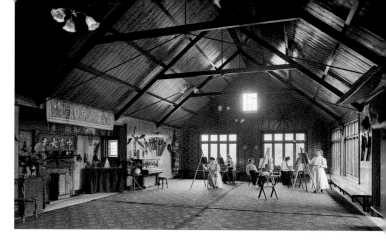

Right and opposite below: The Links Boarding School For Girls, Eastbourne
Miss Margaret Hawtrey was headmistress of The Links in 1907 and she commissioned Bedford Lemere & Co. to take these photographs in that year, presumably for a prospectus. (Historic England Archive)

North End School, East Grinstead

Halsford House (today the site of roads The Stennings, The Timbers and Gwynne Gardens) at the time of this photo in 1874 would become the home of North End School. The school, on London Road in East Grinstead, was built to fill the need for a mixed elementary school of up to 100 pupils by Mary Stenning, who is presumably the oldest lady here with the hat, accompanied by other members of her family. They would have been grieving the death of Mary's husband William, who died in 1874, leaving Mary as head of the family until her death in 1891. The family made their money from timber and running a sawmill on East Grinstead Common, and educating the children of their workers was one of the ways they invested the money back into the community. It opened in 1884 as a Sunday school, and became a proper school the following year, remaining so until its relocation in 1955 to Windmill Lane where it became St Mary's Church of England School. Fledglings Nursery today occupies part of the site. The timber yard also moved to Robertsbridge in the 1950s and is today remembered by the road name The Timbers. (Historic England Archive)

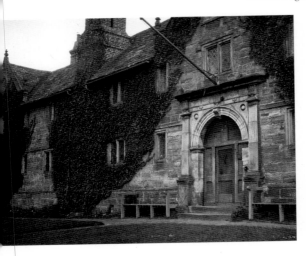

Left: Sackville College, East Grinstead
A view of the south front and main entrance of Sackville College, noted as Sackville Hospital by the photographer. (Historic England Archive)

Below: Warnham Court, Warnham

Warnham Court School was built in 1828 as Warnham Court, most likely by the architect P. F. Robinson, and was added to in 1866 by Arthur Blomfield. In 1947 the owner sold the house and estate, partly due to the disrepair it had fallen into during requisition in the Second World War. A boarding school was subsequently set up there on the instigation of London County Council by 1952, who purchased the house and some land for £21,755 and set up a 'Residential School for Delicate Children' after a major refurbishment taking five years. This meant it was attended by children with asthma or, as was common in the years after the Second World War, children recovering from tuberculosis. It was felt that the London children would benefit from the good country air of Sussex and the facilities that the school could offer. The school closed in 1997 and the estate was sold to developers. Today the house has been turned into apartments and more houses have been built on the site of the education block. (Historic England Archive)

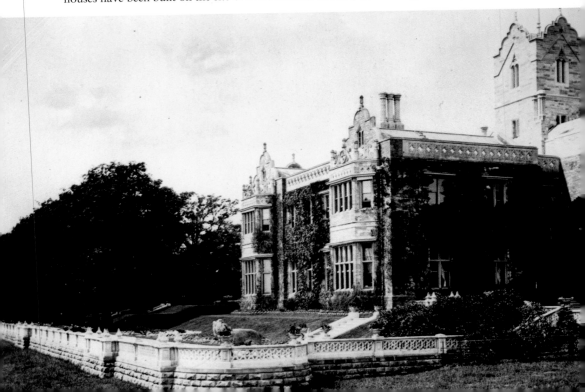

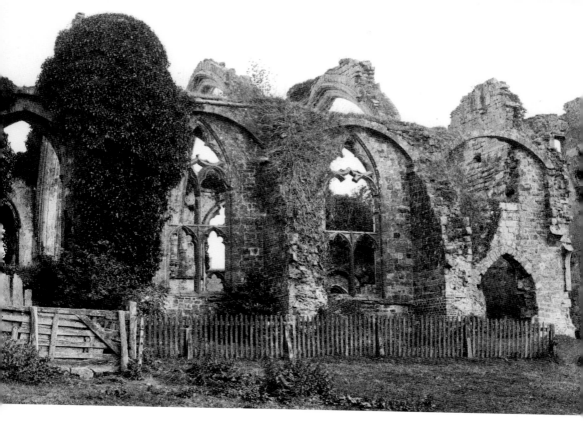

Mayfield School

The ruins of the former Archbishop's Palace before the site was redeveloped. The medieval palace's ruins were converted into a convent and school by E. W. Pugin in 1863–66, making it the first pre-Reformation building to return to Catholic use after the Relief Act. The old palace was originally a holiday residence of the Archbishop of Canterbury during the fourteenth and fifteenth centuries, but during the Reformation it became the property of Henry VIII. Thomas Gresham lived there and Elizabeth I visited him. It has been called the Mayfield School since 2015 and remains an independent school today. (Historic England Archive)

Battle Abbey School

Here we see a man leaning against a sundial by the east front of Battle Abbey School, which incorporates the west side of the cloisters of Battle Abbey. The picture was taken between 1850 and 1920 and, from its age, it is likely to date towards the early years of that time period. (Historic England Archive)

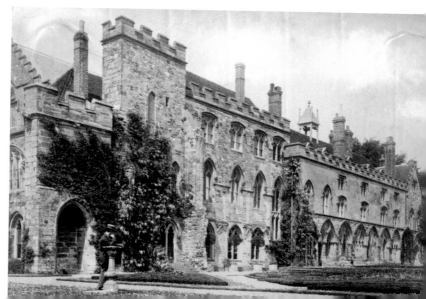

Brickwall House, Northiam

Thanks to the seemingly never-ending energy of Nathaniel Lloyd, owner of Great Dixter from 1910 to 1933, we have a glimpse of the eighteenth-century door shell hood above the entrance of the wonderfully named Brickwall House in Northiam. The Grade I listed building is today jointly used as a school for dyslexic children (Frewen College) in term time and a wedding venue in the school holidays. Its beautifully ornate entrance provides the reason for Lloyd to have got his camera out. His own house was at this time (1915) being used as a war hospital and so perhaps getting out and about photographing nearby architecture provided some respite for Lloyd from the suffering of his injured guests. Brickwall has the date 1616 on its main front and was home for three centuries to the Frewen family, hence the name of the school, which was originally Down House School. (Historic England Archive)

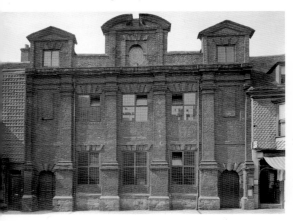

Peacock's School, High Street, Rye

Peacock's School, here photographed on 27 April 1916, reminds us that so many of the wonderful buildings used as schools are no longer, or have even been demolished. Rye's educational roots go back to 1636 with Rye Grammar School, which was founded by Sir Thomas Peacock, with links to both Peacock's and Sanders' School. The Grammar School merged with Rye Secondary School in 1967 to form Thomas Peacock's Comprehensive, then Community College, and since 2017/18, joined by Rye Studio School, just Rye College. The building shown here is today another much-loved institution: a record shop. (Historic England Archive)

People and Their Places

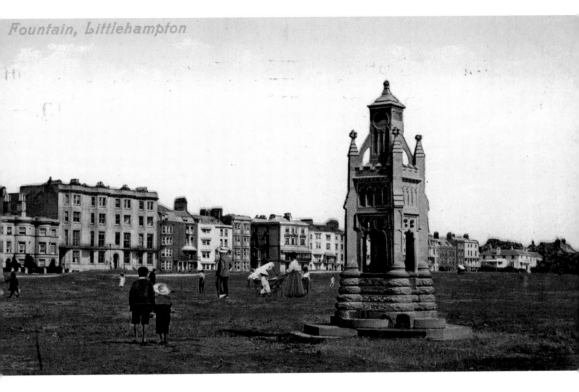

The Fountain, Littlehampton
The east of Littlehampton, away from the crowds, harbour and amusements, is a real treasure. The architecture is at its most pleasant, there is plentiful green space and, as we see here in this image from some point between 1904 and 1909, there was even once a delicately styled fountain, long since removed. Unlike Worthing, which has lost many of its original seafront buildings, these buildings still remain largely unchanged today. (Historic England Archive)

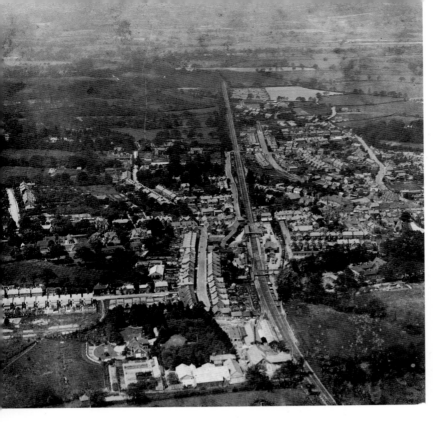

Crawley
A general view of
Crawley town from
the east, taken in
1920, before its
post-war expansion.
(© Historic
England Archive.
Aerofilms Collection)

Below and opposite above: Bandstand, The Carfax, and St Mary's Church, The Causeway,
Horsham
The people in the picture opposite above are in one of the nicest parts of Horsham today, looking
south-west along The Causeway towards St Mary's Church. Horsham has seen much change
throughout the town but still retains glimpses of what it must have been like at the turn of the
nineteenth and twentieth centuries. (Historic England Archive)

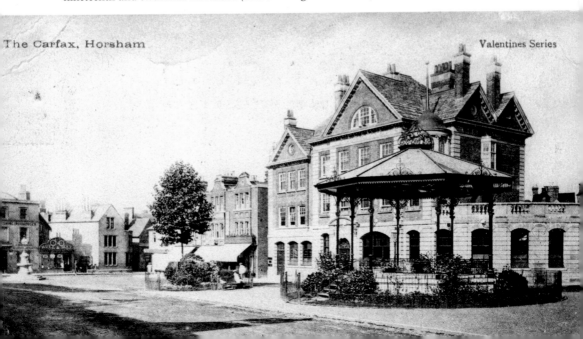

The Carfax, Horsham Valentines Series

Below: The Fig Gardens, (West) Tarring, Worthing
A view of the Fig Gardens ('Ancient Fig Gardens' as the sign says) in Tarring High Street. The current trees date back to 1745 but an old myth persists that the original trees were linked to St Richard, the thirteenth-century Bishop of Chichester, or even Thomas Becket, Henry II's 'Turbulent Priest' (1120–70), as the manor of Tarring was once owned by the Archbishops of Canterbury, being given to them in the tenth century by King Athelstan. The Fig Gardens are still privately owned today and people can view the garden, which lies within the grounds of Bishop's Garth, South Street, Tarring (a Grade II listed building), and Nos 1–2 The Fig Garden, Bishop's Close, for free every June. (Historic England Archive)

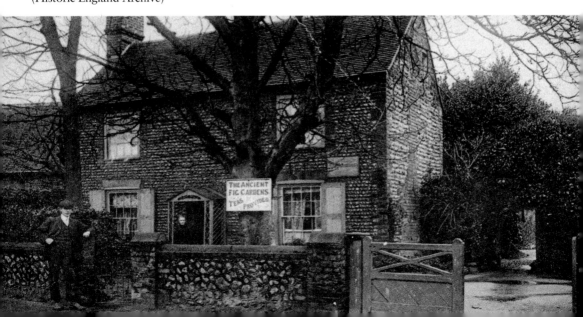

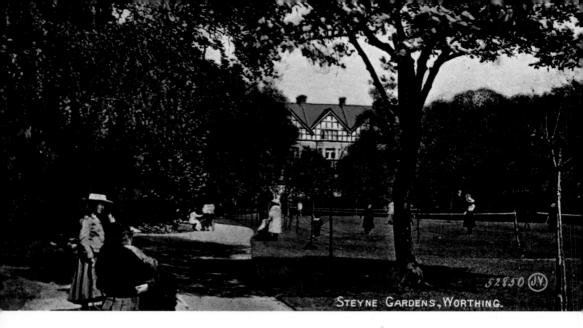

Steyne Gardens, Worthing

Steyne Gardens, Worthing

East of Tarring in Worthing, and once referred to as 'Singers' or 'Stringers', is the central green space of Worthing seafront. It took the Scandinavian name from Brighton that's used for its 'stoney ground' and spelled it with a 'y' instead. Bognor soon followed suit; Brighton's seafront open space is today called 'The Old Steine' subsequently to differentiate. Worthing's Steyne here is truly being used as a recreational park with badminton being played by young Edwardian ladies. The newly built Broadwater terrace of shops and flats peak from behind the fully grown trees on the Brighton Road. This replaced Worthing's first manor house, Warwick House, which was demolished in 1897 but is still remembered in the names of the streets in this part of central Worthing. The ladies gazing eastwards would be looking at the entrance to an air-raid shelter if this was the Second World War. (Historic England Archive)

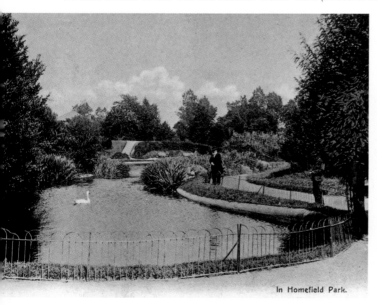

In Homefield Park.

Homefield Park, Worthing

Further east still across Worthing is Homefield Park. Today it has been encroached upon by the expansion of Worthing Hospital (which it is north of) and the lake here, fed by the Teville Stream, has since been covered over, although the park suffered floods several years back as the water level rose once again. Those seeking a lakeside park life today in Worthing need to travel east even more to Brooklands Park on the border with Lancing. (Historic England Archive)

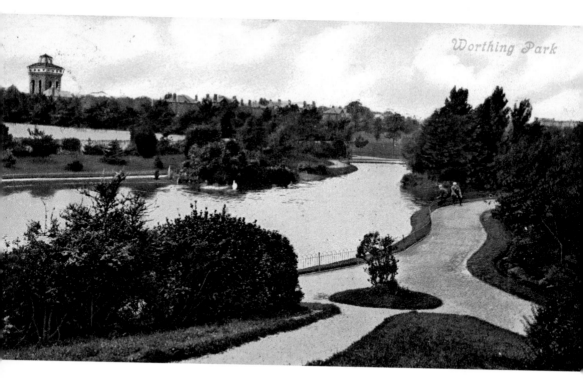

Homefield Park, Worthing

Another view of Homefield Park in its glory days, this time from the north looking across at a marquee tent where Worthing Hospital is today and towards the Victorian park-side villas at the south-west end of the park. Missing from this view today is the water tower in the distance, which Tower Road now takes its name from. This image was taken only a few years after the typhoid outbreak in Worthing in 1893, which caused over 120 deaths and led to the tower's eventual demolition – it was found to be the source of the enteric fever (as the disease was also known). (Historic England Archive)

St Mary de Haura Church, Shoreham

Despite its age, St Mary's is not the oldest Shoreham church, being built in the 'new' town of Shoreham-by-Sea that replaced the less accessible 'old' Shoreham, which is by the Old Toll Bridge over the Adur. As the Adur became less mighty a waterway and the port of Bramber and Steyning ceased to be accessible on the tides, a coastal port became more vital. This is why St Mary's is 'of the harbour' (de haura). New Shoreham was to face its own period of decline and St Mary's was once much larger. Here we see the view from the south-east showing the south elevation of the church and a since lost pub. (Historic England Archive)

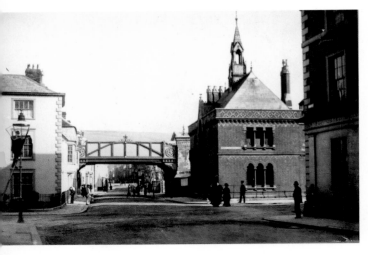

Lewes Railway Station
Lewes railway station was in a very different position in the Victorian age as we see here, the line crossing opposite the bottom of School Hill. The new station being opened in its current location in 1857 (it was rebuilt in 1889) meant that for a while the town had multiple pubs called the Railway. The old line and station can still be seen on a map of the town in the town's museum at Lewes Castle and the old station site is where the magistrates' court is today, the station having been demolished in the 1960s. (Historic England Archive)

Cliffe High Street, Lewes
Visitors to Lewes today are not usually aware that Lewes was originally two distinct communities: Lewes and Cliffe. They were divided by the Ouse, each once having separate fire services. Further east in Lewes this time and standing on the eastern side of Lewes's oldest bridge, we look down through Cliffe High Street here. Today to the left are the shops and offices for Harvey's Brewery and to the right the first ever in the chain of successful Bill's restaurants, with the John Harvey Tavern, the brewery tap for Harvey's, just out of sight past that in Bear Yard. The yard takes its name from the Bear Inn which existed by the river's edge until its disastrous fire in 1918. (Historic England Archive)

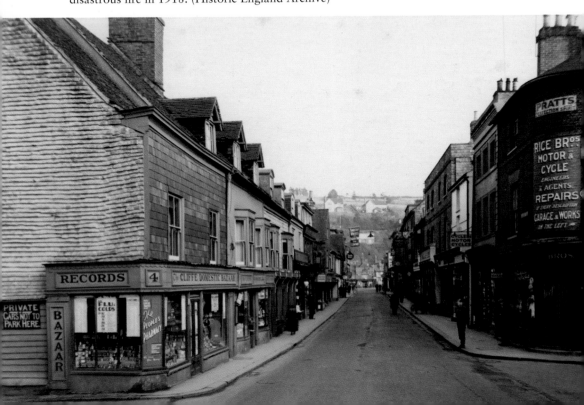

Jack Fuller Country, Brightling

No book on Sussex's history should omit one of the county's larger-than-life figures, that of 'Mad' Jack Fuller MP. Benevolent employer in times of hardship, insulter of the Speaker of the House of Commons, saviour of Sussex buildings, and builder of others, we see here one of his more unusual follies next to St Thomas à Becket Church, Brightling, the pyramid-shaped Fuller Mausoleum he had built as his tomb some years before his death. For many years it was believed he was interred in it sat upright enjoying a meal and a glass of wine, which would have been apt as he was also known as the 'Hippopotamus' for his 20-stone-plus frame, which was said to terrify the officers of Parliament as he approached Westminster. (Historic England Archive)

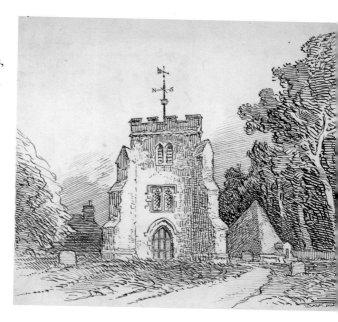

Below and overleaf: Bexhill

Below we see Bexhill Park between 1900 and 1907 and overleaf crowds of people are gathered around the Lane Memorial in Town Hall Square, watching a long-forgotten ceremony at some point probably between 1898 and 1902. The square has been used recently for political events but the lack of political banners suggest this meeting may not be one. Whatever it is, it has certainly gained people's attention as they have climbed out of windows to listen to the speaker or band playing. The Lane Memorial was erected in 1898 in memory of Lieutenant Colonel Henry Lane. This print is one of eleven images mounted on two sides of a detached album page relating to the fountain and house of Colonel Henry Lane. The colour image below dates from between 1902 and 1907 and the area around the memorial has now been landscaped. (Historic England Archive)

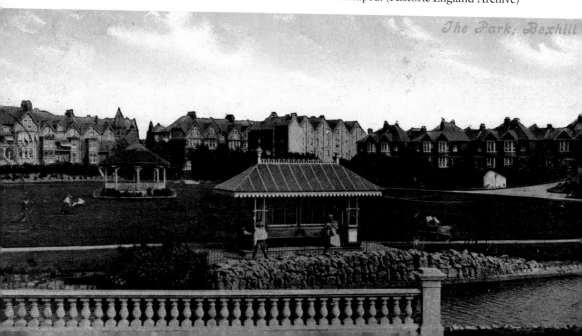

The Park, Bexhill

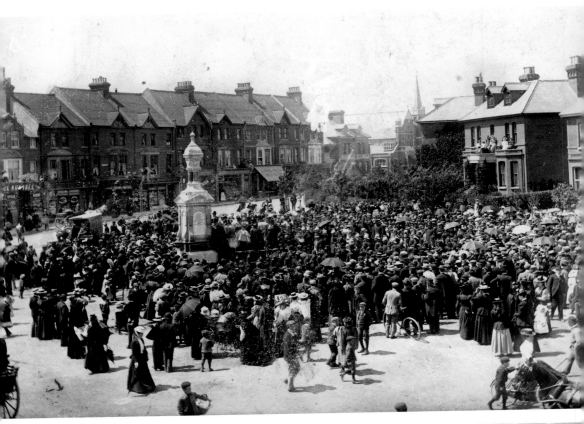

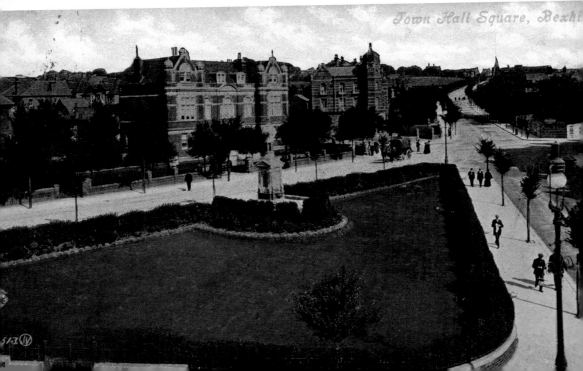

Town Hall Square, Bexhill

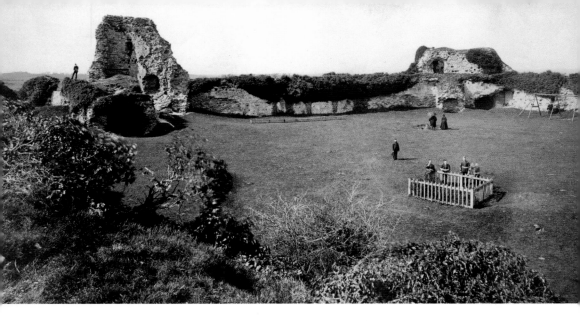

Above: Pevensey
The Victorians here are on a mission. This elevated view looking north-west across the inner bailey at Pevensey Castle towards the gatehouse and north tower shows men in uniform standing by a fenced enclosure in the foreground. On this day in 1899 they were 'in search of the monument of Adrian G (not found)' according to a caption on the reverse of the image. (Historic England Archive)

Below: St Leonards Gardens
Another shot of the lush oasis that is St Leonards Garderns, from a postcard dated 1900–1905. (Historic England Archive)

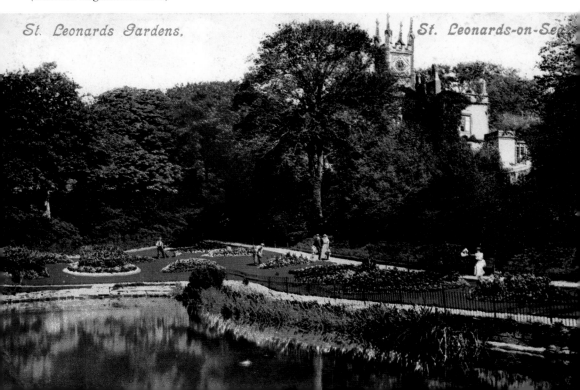

St. Leonards Gardens. St. Leonards-on-Sea

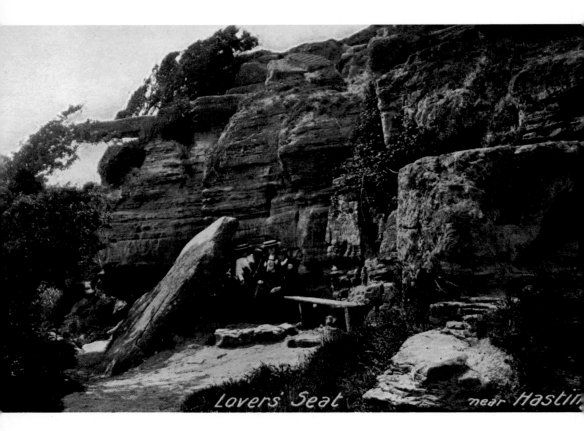

Lovers' Seat, Fairlight
The story of Lovers' Seat is one that tells you never to let a dominant father get in the way of true love. Nor the duties of being in charge of a Royal Navy ship for that matter. Back in the eighteenth century Lieutenant Charles Lamb, RN of Rye, fell in love with Elizabeth Boys, the daughter of Samuel Boys of Hawkhurst. To keep his daughter away from Lamb he sent her away to Fairlight Place on the coast, near Hastings. A coastal location was just what the officer needed and as ship's captain on coastal anti-smuggling patrols the love-struck lieutenant could escape the ship and meet Elizabeth at a secluded spot on the rock cliffs at Fairlight. Where they met was a natural ledge in the rocks and so it became known as the Lovers' Seat. Eventually the couple eloped to London to marry and Samuel Boys never blessed the union, which lasted for twenty-eight years until Lamb's death by drowning. (Historic England Archive)

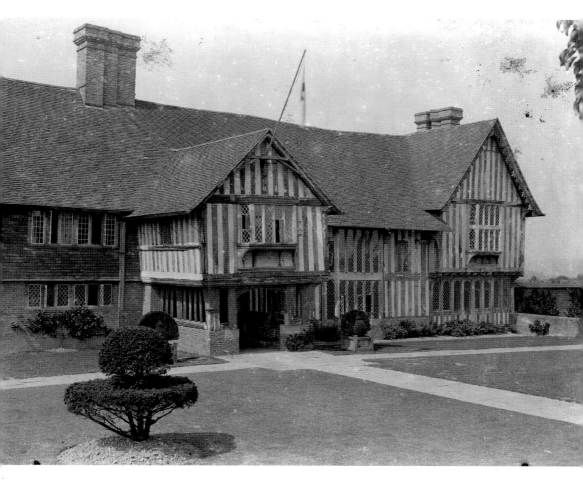

Above and overleaf: Great Dixter, Northiam

The Lloyd family of Great Dixter deserve a book of their own and the public's thanks, as without the avid passion for photography of Nathaniel Lloyd, a huge void would exist in the Historic England archive for Sussex. Nathaniel and Daisy Lloyd bought Great Dixter in 1910 and brought up six children there where they all developed a passion for the house and especially its garden. This is not surprising as a house has been on the site since 1220 and the oldest part of the house, the Great Hall, dates from 1450. Christopher Lloyd (1921–2006), the famous gardener, was the youngest child and was born in the north bedroom of the Lutyens wing. For the rest of his life Dixter was his home with his niece and he became Britain's most famous gardener due to the decades of his columns for *Country Life*. Great Dixter today is truly worth a visit as one of the most documented of all Britain's gardens. (Historic England Archive)

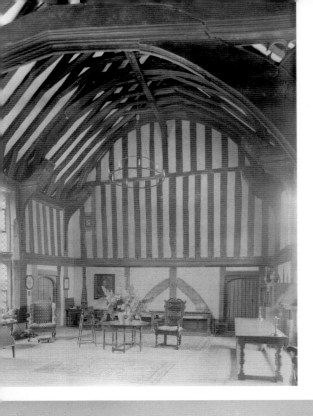

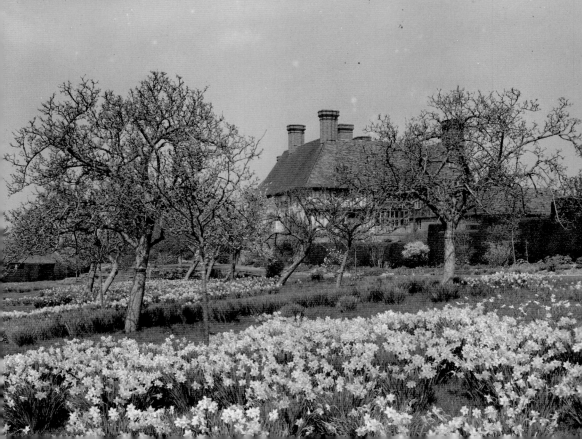

Work and Industry

E. Martin & Sons
A view of E. Martin & Sons' boatyard in the Chichester area of West Sussex, looking from an elevated position out towards a tidal area, probably the Chichester Channel, with small boats beached in the foreground and two men among them. (© Historic England Archive)

Quayside, Chichester District
A view of two men talking at a quayside in the Chichester district of West Sussex, possibly on the Chichester Channel. Also showing a masted boat at the quayside almost submerged in thick silty tidal mud, and a view of the tidal area in the background.
(© Historic England Archive)

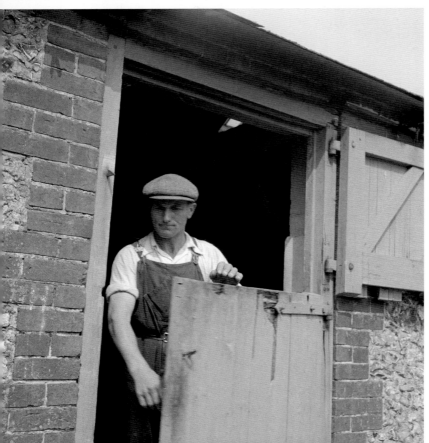

Labourer, West Sussex
An informal portrait of an unknown farmer or rural labourer wearing a cap and dungarees, showing him about to exit a small outbuilding through a heck door, photographed in the Chichester area of West Sussex.
(© Historic England Archive)

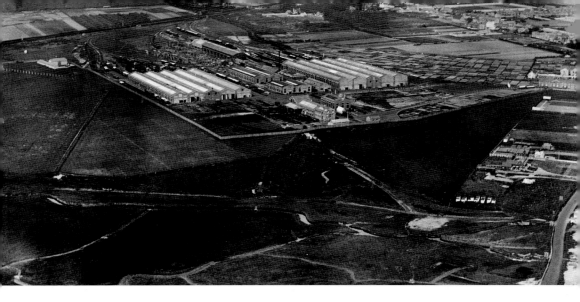

Above: London, Brighton and South Coast Railway Carriage Works
Taken from the south-west in 1920, this Britain From Above image shows the sheer scale of railway carriage construction in Lancing in the early twentieth century. Opening between 1908 and 1912, the railway wagon and carriage works were in what is now the Lancing Business Park, also known as the Churchill Industrial Estate. Unlike its sister works at Brighton, it only experienced a short life, closing in 1965 as part of British Rail's 1963 Beeching Plan. (© Historic England Archive. Aerofilms Collection)

Below: Tea Gardens, Bramber
One of Sussex's main industries has become heritage tourism, which boomed in the Victorian age with the event of the railways making sites such as Bramber Castle hugely popular. Tea gardens sprouted up everywhere tourists would venture, and any excursion to Bramber via the now Beechinged Bramber station included a visit to one. Bramber even had a tea garden in the castle grounds at one point, with a small sit-on railway, but here we look at Friar's Tea Gardens south of Bramber High Street in a site partly occupied by buildings today and partly by the gardens of the Old Tollgate Hotel, Bramber. (Historic England Archive)

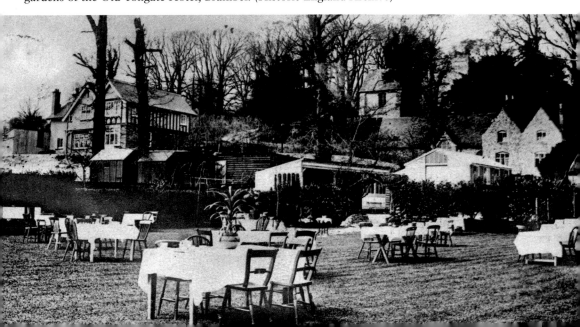

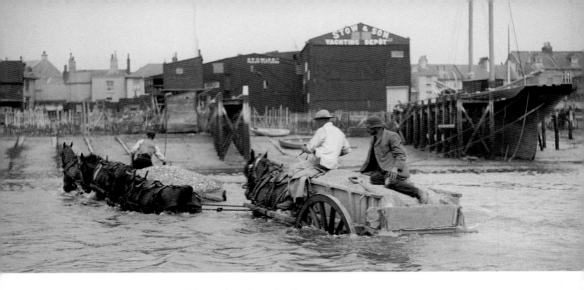

Stow & Son Yacht Builders, Shoreham-by-Sea
Two industries on show here, with the horse and cart bravely pulling a load of ballast through the low tide, presumably so the yacht that Stow & Son are working on has the correct amount of ballast below deck. Boatbuilding had something of a resurgence in Sussex in the nineteenth century and survived here into the twentieth too. The horses seem remarkably calm about their partly submerged journey and must have been used to crossing the much lower Aldrington basin here. The lock system on the harbour today ensures the water level is much higher for the larger shipping the harbour now experiences and so such a scene would be impossible in the present day (not to mention rightly protested at by animal rights activists). (Historic England Archive)

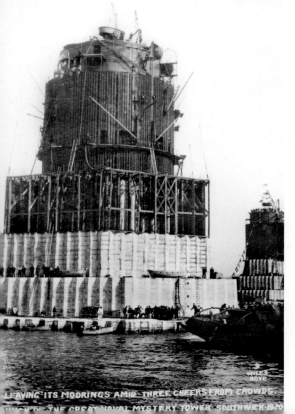

The Mystery Tower, Southwick
A very different industrial use of the harbour here in this view showing the launch of the Mystery Tower from Southwick. The Mystery Tower was one of two towers built during the First World War as part of a scheme to defend the country against German U-boats. The towers were completed just before the end of the war, and not being needed for their original purpose, the one depicted in this image was floated over the Isle of Wight, where it now forms the Nab Tower Lighthouse. (Historic England Archive)

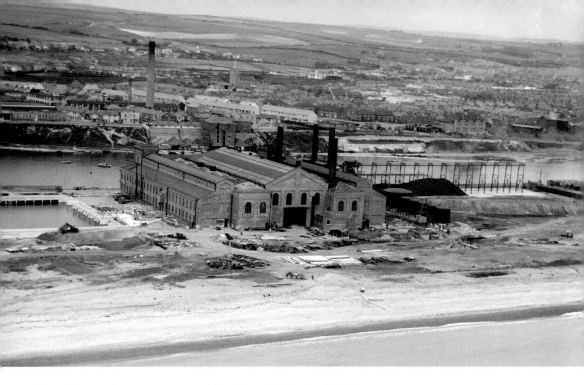

Above: The Brighton Corporation Electricity Works, Southwick
Not moving far geographically from the last location, we see here the first power station at Southwick, which would become known as Brighton A in 1906 and was succeeded by the much larger Brighton B coal-fired power station in 1948. The gas-powered power station at the harbour today was built in 2002. This photo was taken in 1927. (© Historic England Archive. Aerofilms Collection)

Below: Violet Nurseries, Henfield
In this view we see the exterior of the thatched cottage at Violet Nurseries. The Violet Nurseries, founded around 1903, supplied violets, carnations and lavender around the world and had Queen Mary as one of their patrons. The photograph was taken for G. Street & Co., advertising agents. (Historic England Archive)

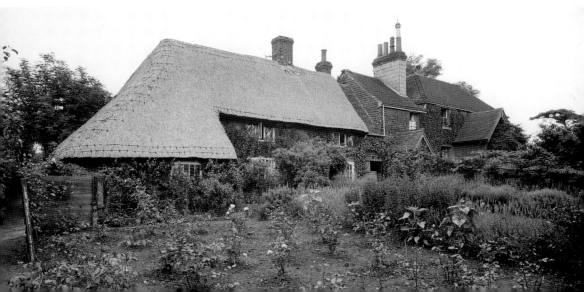

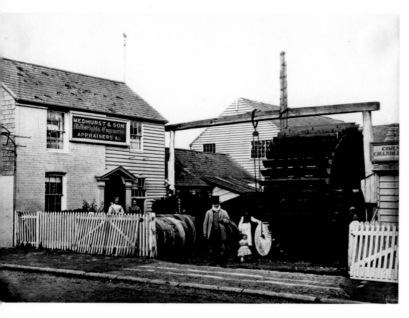

The Watermill, Lewes
The millwright Mr Medhurst and his family standing outside his premises on Western Road, Lewes, showing that watermills were still in use as recently as the late nineteenth century. The photographer is the illustrious Edward Reeves, whose descendants still run their photography shop in Lewes High Street. Watermills have a long history in Sussex. At the time of the Domesday Book, Sussex had lots of them but no windmills yet. (Historic England Archive)

The Brighton County Borough Psychiatric Hospital
Also known as Sussex's County Lunatic Asylum, the County Psychiatric Hospital in Haywards Heath would become St Francis' Hospital and opened in 1859. It was built by H. E. Kendall Junior. The hospital, which once had its own farm, brewery and bakery, is photographed here in 1932 and closed in 1995. Since 1998 it has been the Southdown Park housing development but the yellow- and red-brick Venetian-style building is still one of the county's largest and most impressive Victorian developments. The hospital led the way in treatment of the insane, rejecting chains and straitjackets for pet therapy, furniture making and getting patients to join the hospital's very own band. Its gardens, spacious landscape and views of the Downs were said to work wonders. It was even said to be completely self-sufficient except for tea and sugar. (© Historic England Archive. Aerofilms Collection)

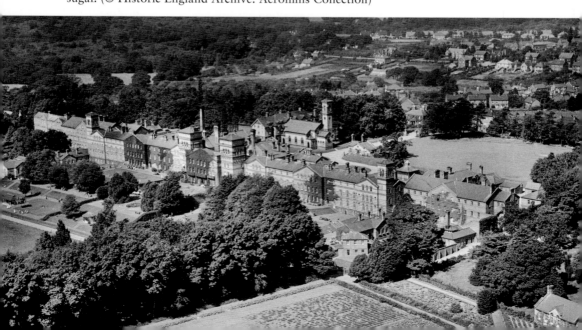

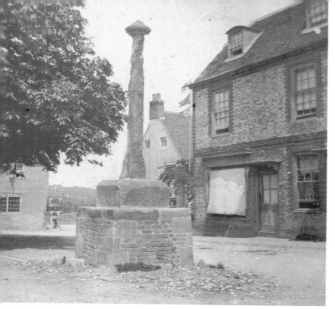
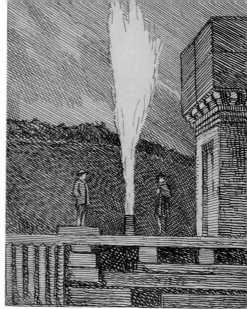

Above left: Market Cross, Alfriston
Recycling is now a big Sussex industry, but recycling building materials is nothing new. Alfristons's Market Cross in Waterloo Square, pictured here, has the following inscription on the back: 'The portions that have disappeared are understood to have been employed in making drains and doorsteps!' (Historic England Archive)

Above right: Railway Tunnel Entrance, Heathfield
Just to show the current trend of fracking is not an isolated phase of fascination with underground gas reserves, here we have an illustration from 1896 of two men standing by the natural gas outlet discovered near the entrance to the railway tunnel in Heathfield. (Historic England Archive)

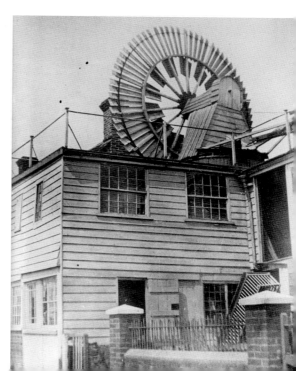

Carpenter's Workshop, Punnetts Town, Heathfield and Waldron
The wind wheel on the roof of Cornford's weatherboarded carpenter's workshop in Punnetts Town, Heathfield and Waldron, East Sussex. The wind wheel supplied power to a circular saw in Mr C. Cornford's carpenter's shop. The mechanism was installed around 1909 by F. Neve & Sons and was dismantled in 1916. The workshop remained in use until the 1970s. (Historic England Archive)

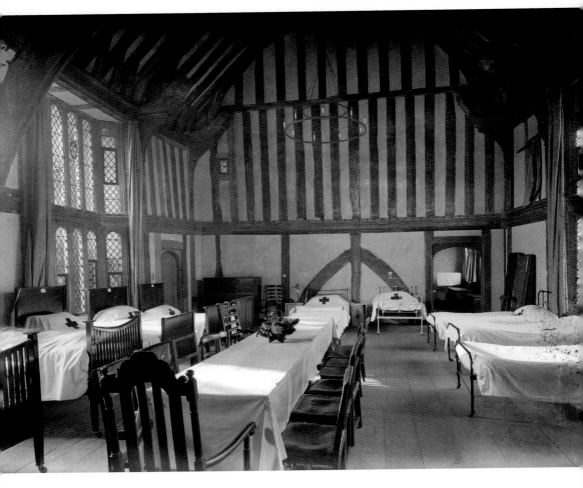

Above and opposite above: Great Dixter, Northiam

These images remind us that the role of Sussex in the war effort during the First World War was a medical one. Towns such as Brighton were well known as hospital towns for the Western Front, but the fact that somewhere as far away from the coast as Great Dixter and a venue as small as the Great Hall was being used as an army hospital demonstrates the sheer numbers of casualties. For four years during the First World War part of the house became a hospital and a total of 380 wounded soldiers passed through the temporary wards created in the Great Hall and the solar. In the second picture we see the medical staff and patients near the end of the war in July 1918. This is part of the extensive collection of photos by Nathaniel Lloyd of Great Dixter that dominate the Historic England Archive. (Historic England Archive)

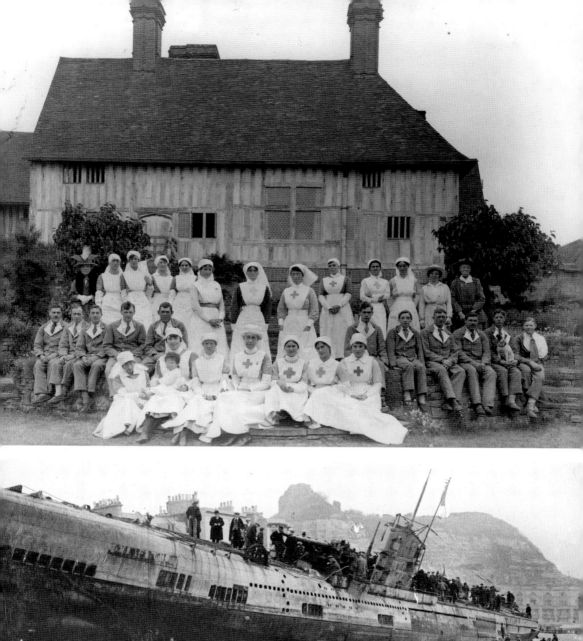
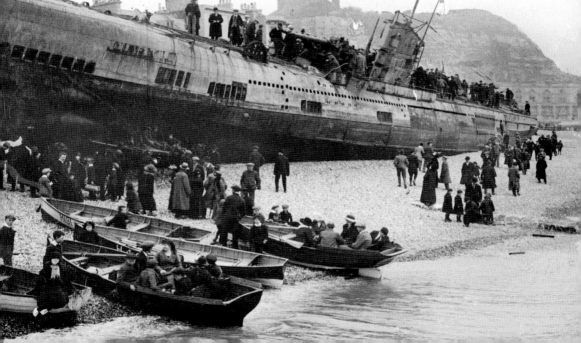

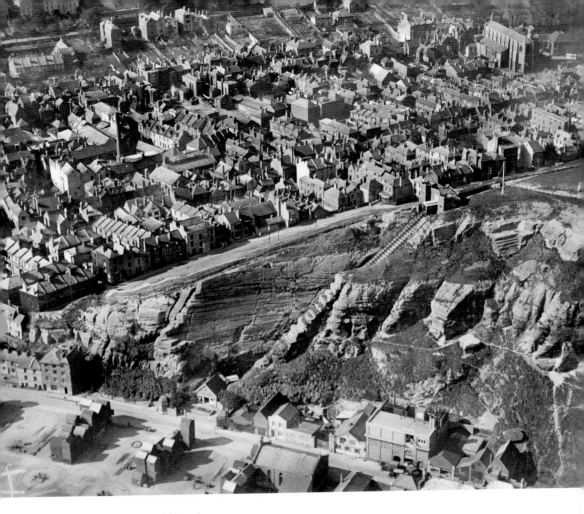

Above: The East Cliff Railway

These fishermen's huts next to the Stade give an idea of a more typical Sussex industry returning to normal once the First World War was over. It also reminds us of Brighton and Worthing's lost fishing villages below their cliffs. Also in this picture is an unusual example of industry here for Sussex – East Hill Railway. A similar railway existed to take visitors up to Devil's Dyke the only one of its type remaining today. The community of fishing huts were still known as the Fisherman's Net Shops, a term little used now, but on maps of fishing settlements lost to the Sussex sea, such as Worthing Shops, from the early 1700s. On page 91 we see the fishermen's huts from the more westerly perspective of something vital for Hasting's fishing industry – the Lifeboat House. (© Historic England Archive. Aerofilms Collection)

Previous page below: U-118, Hastings Beach

A lot of industry would be needed to deal with the shipwrecked German U-boat U-118, which ran aground on Hastings Beach on 15 April 1919. Small boys in Hastings terrorised neighbours nearby with the noise of a constant barrage of stones being thrown at the submarine until its dismantling for scrap. She was due to be French scrap – she was being towed to a scrapyard in France when her cable snapped. The French lost a valuable commodity and Hastings gained a busy tourist attraction, which sadly killed the two coastguards who showed visitors around the exterior of the boat. It was thought gasses from the sub's batteries led to their untimely deaths. The First World War could still claim lives even after the Armistice. (Historic England Archive)

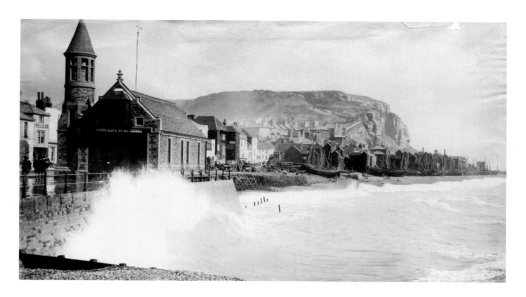

Above and below: Lifeboat House, Hastings

Hastings, like many coastal Sussex communities, was made up of two communities – fisherfolk and farming people. Worthing's motto, 'from the land fullness and from the sea health', even spells out the importance of both of these. Hastings' two communities haven't always got on, but they were not alone – Brighton's agricultural types objected to paying for sea defences to help defend their fishing townspeople when the town faced serious coastal erosion in the 1700s. In this engraving below we see a farmworker and his horse-drawn wagon moving inland with his produce along the Old London Road of Hastings, the tower of All Saints' Church dominating the semi-rural scene behind. The other figures in the scene seem to be discussing work or commerce. (Historic England Archive)

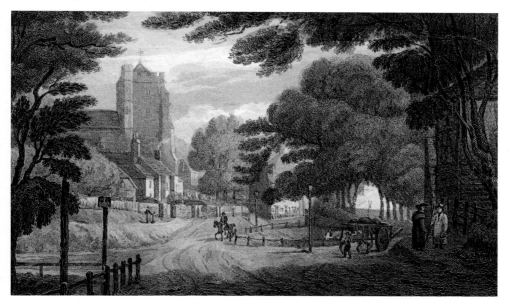

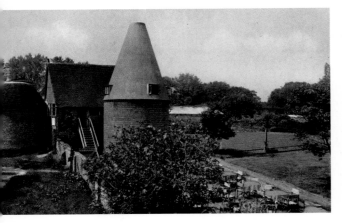

Oast House, Horam
This image from the early twentieth century reminds us that although Kent was traditionally hops country, the very east of Sussex grew them too. Oast houses like the one here, used for storing the hops, are the legacy of this industry. Today most tend to be desirable residences or exclusive guest houses but they still remind us of this once huge industry that employed many Londoners each year and often gave them their first taste of Sussex. (Historic England Archive)

Rye
As we progress from the combustion engine-motorised age to the electric-motorised age, we forget how quiet the streets used to be and the reliance on four-legged transport until the twentieth century. Mermaid Street, ascending behind the horse and cart here, thankfully just has the odd brave driver only seeking access to the Mermaid Inn or their property and it remains mostly a pedestrianised street, but Rye is encircled today not by the rivers and shoreline that once made it practically an island (its name comes from 'at the island'), but by the thrum of vehicles. The centre of Rye remains charming, however, and another reason to visit the site is that the large building that takes up most of the right of the photo is today the Ship Inn. (Historic England Archive)

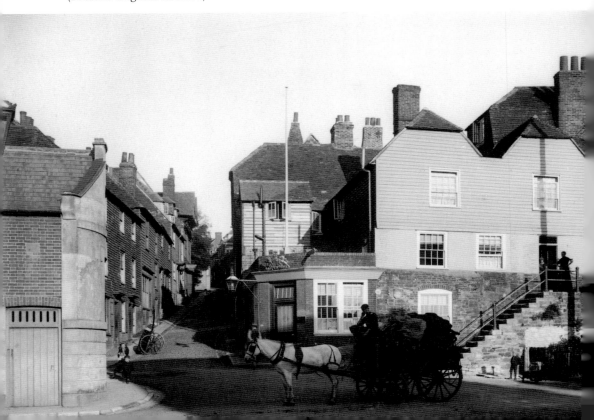

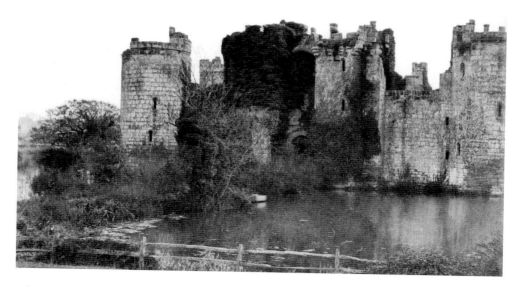

Above and below: Bodiam Castle

It seems fitting to end with a reminder of all the work that has gone into saving, conserving and sometimes rebuilding Sussex's heritage, as well as the hard work of the heritage industry today such as Sussex Archaeological Society, the National Trust and especially Historic England and English Heritage. The castle was built by Sir Edward Dalingridge in the years following 1385. It was partially dismantled during the Civil War and the state of the castle here reminds us that 'Mad' Jack Fuller saved the castle from demolition for building materials (perhaps we should call him 'Honest' Jack as he labelled himself instead). It also reminds us of the huge effort needed to restore the castle, which hadn't started by the time of this image, *c.* 1858, and would need both time in the nineteenth and twentieth centuries after its purchase by Lord Curzon. It was finally restored as we see in our final picture and given to the National Trust in 1925. Thanks should go out to all these people over the decades and to those who will endeavour to protect Sussex's past in the decades and centuries to come.

You will notice two places that have provided much work and industry for Sussex folk have been omitted. The first is Eastbourne, which fellow author Kevin Gordon has covered separately in this series, and the second is Sussex's central city, Brighton and Hove. The latter is not caused by a lack of archive material, but instead as we will be publishing a 'Brovian' edition of the *Historic England* series shortly. (Historic England Archive)

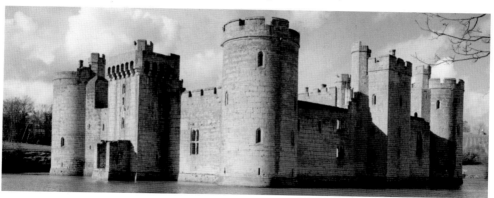

Acknowledgements

I am most grateful to Angeline Wilcox at Amberley for commissioning this book and her timeless support and advice. Also to Jenny Stephens and Marcus Pennington at Amberley for their hard work on the design and layout of the book. Thanks to my friend and fellow Amberley author Antony Edmonds for lending his wise eyes and encyclopaedic knowledge of Worthing for those sections on South Street and to Terry Loftus for being my Hastings researcher. Thanks also to Alyson Rogers at Historic England Archives for support when the website hit some gremlins. Finally, my heartfelt thanks and love go as always to my family, Laura, Seth and Eddie, for their patience, support, encouragement and ability to put up with me rambling on about the places in this book.

About the Author

Kevin Newman is a Sussex author, tour guide and historic events consultant who has written five books for Amberley. He has also written school history resources and textbooks and contributed history supplements to the *Argus* newspaper in Sussex as well as to *Sussex Life*, *Exclusively British* magazine and for Brighton and Hove Albion FC publications. His next book for Amberley is *A–Z of Brighton and Hove*.

Other books by Kevin Newman:
Brighton and Hove in 50 Buildings
Secret Brighton
Lewes Pubs
50 Gems of Sussex

Forthcoming books:
A–Z of Brighton
Historic England: Brighton and Hove

About the Archive

Many of the images in this volume come from the Historic England Archive, which holds over 12 million photographs, drawings, plans and documents covering England's archaeology, architecture, social and local history.

The photographic collections include prints from the earliest days of photography to today's high-resolution digital images. Subjects range from Neolithic flint mines and medieval churches to art deco cinemas and 1980s shopping centres. The collection is a vivid record both of buildings that are still part of everyday life – places of work, leisure and worship – and those lost long ago, surviving only in fragile prints or glass-plate negatives.

Six million aerial photographs offer a unique and fascinating view of the transformation of England's towns, cities, coast and countryside from 1919 onwards. Highlights include the pioneering photography of Aerofilms, and the comprehensive survey of England captured by the RAF after the Second World War.

Plans, drawings and reports provide further context and reconstruction artworks bring archaeological sites and historic buildings to life.

The collections are housed in a purpose-built environmentally controlled store in Swindon, which provides the best conditions to preserve archive items for future generations to enjoy. You can search our catalogue online, see and buy copies of our images, as well as visiting our public search room by appointment.

Find out more about us at HistoricEngland.org.uk/Photos
email: archive@historicengland.org.uk
tel.: 01793 414600

The Historic England offices and archive store in Swindon from the air, 2007.